THEN & NOW

TEMPE

THEN & NOW

TEMPE

Linda Spears, Frederic B. Wildfang,
and the Tempe History Museum

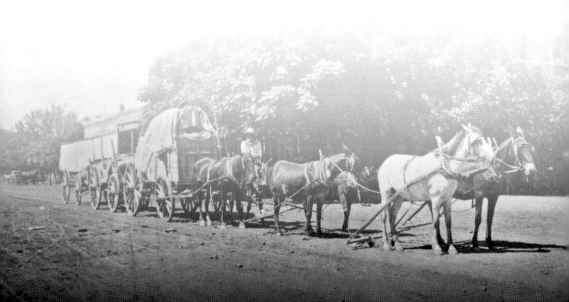

To Evelyn
(1941–2010)

Library of Congress Control Number: 2010926986

Published by Arcadia Publishing
Charleston, South Carolina

Printed in the United States of America

For all general information, please contact Arcadia Publishing:
Telephone 843-853-2070
Fax 843-853-0044
E-mail sales@arcadiapublishing.com
For customer service and orders:
Toll-Free 1-888-313-2665

Visit us on the Internet at www.arcadiapublishing.com

ON THE FRONT COVER: Both cover photographs feature the most prominent landmark in Tempe, known variously as Hayden's Butte, after the name of the town founded by Charles Hayden in the early 1870s; Tempe Butte, after the name given to the town by Englishman Darrell Duppa in 1879; and 'A' Mountain, after Arizona State University, established in 1885. Tempe Bridge was built in 1933. The Hayden grain elevators were built in 1951. Town Lake was completed in 1999. (Then image courtesy of the Tempe History Museum; now image courtesy of Linda Spears.)

ON THE BACK COVER: In this view from Tempe Butte, the Laird and Dines Drugstore can be seen on the southeast corner of Mill Avenue and Fifth Street. It was built in 1893. Across Mill Avenue is the Tempe Hardware building, built in 1898 and still standing. The empty lot on Fifth Street in the foreground is now the location of the Mission Palms Hotel. (Courtesy of the Tempe History Museum.)

CONTENTS

ACKNOWLEDGMENTS

I first started visiting Tempe for a city fix on off-duty weekends while teaching at a rural boarding school in northern Arizona in 1969. I first started spending part of my winters there when I moved from California to Arizona with my wife, Diane, in 1989. Since then, I have returned to Tempe regularly.

Mainly I keep coming back because of the hospitality extended to me by my wife's good friends and associates: Linda, Rita, and Evelyn Spears. It has been a great pleasure to become acquainted with Linda, Rita, and Evelyn, now my good friends and associates—particularly Linda, who kindly provided direction and the contemporary photographs for this book about Tempe.

Secondary sources consulted for this book include Images of America: *Tempe*, by Shirley R. Blanton; *Phoenix 1870–1970 in Photographs*, by Herb and Dorothy McLaughlin (editors); and *Phoenix*, by Thomas E. Sheridan. Primary sources consulted are available at the Tempe History Museum.

Unless otherwise noted, all the historic images for this book are published here courtesy of the Tempe History Museum. Thanks goes to Richard J. Bauer at the museum for his invaluable help.

The contemporary photographs have been provided by my friend, photographer, Tempe accountant, and former Tempe city councilwoman, Linda Spears.

Special thanks go to Tempe resident and U.S. Representative Harry E. Mitchell for writing the introduction to this book.

—Frederic B. Wildfang

INTRODUCTION

Tempe, Arizona, has become a major urban area. Landlocked, its 40 square miles are bounded by Phoenix to the west and south, Scottsdale to the north, Mesa to the east, and Chandler to the east and south. Because of its physical limitations, Tempe has developed and redeveloped differently from the surrounding cities. Tempe very much remains the approachable town that attracted its first settlers.

The Hohokams were the first people to appreciate Tempe's unique location. The river provided water for their crops, and the butte provided a safe place to escape the rising river and ensuing floods. Though their disappearance remains a mystery, the reasons they came are not. Those very attributes brought Charles Hayden to the same spot. Hayden chose to build his flour mill in the place where the Hohokams had dwelt. The butte that protected the tribe would become the most identifiable landmark in Tempe. From its top, a panorama of the Salt River Valley is visible. Where there were once deserts and small farms, skyscrapers now rise. Ferries have been replaced by bridges to move automobiles across the Salt River. Passenger trains have been replaced by modern light rail.

Arizona State University (ASU) has played a major role in Tempe's history. Not only has ASU impacted the physical development of Tempe, as evidenced by many of the now photographs, but it has also played a major role in the people who have relocated to Tempe and become major influences in its development.

My grandfather was a first-generation Tempean. In addition to being a small business owner, he served in the Arizona state legislature. I learned a love of governance and Tempe at his knee. I delivered newspapers to the homes of small-town Tempe as a child. I went to college and became a high school government teacher at Tempe High School. I raised my family in Tempe. In 1970, I was first elected to the Tempe city council, and I became mayor in 1978, serving until 1994. Today, my son serves as a Tempe councilman.

During the time I was on the Tempe council, Tempe underwent a major change with the redevelopment of downtown's Mill Avenue. Mill Avenue became the corporate home of America West Airlines (now U.S. Airways). Class-A retail and office space replaced the mom-and-pop businesses of yesterday. Classic structures were restored and became homes to major chain establishments. Mill Avenue became a destination, much like Hayden's Ferry was at the start of the 20th century.

Tempe's most dramatic redevelopment occurred in the mid-1990s, when the political decision was made to create Tempe Town Lake by damming the Salt River within Tempe's borders. The lake was created by installing inflatable dams at each end. These dams can be lowered to allow for the normal flow of the Salt River, which controls flooding. When raised, the dams allow the lake to maintain a constant level for recreational purposes.

The original plan for the lake was an ASU School of Architecture class project. Students planned for the now normally dry riverbed to once again become a source of commerce for Tempe by providing a lake and lakefront property.

The lake today is a reflection of Tempe's past, when Charles Hayden stood on the banks of the Salt River and decided to settle there. Now those same banks are home to modern buildings that house major companies and Tempe residences.

The Tempe Town Lake has become a main gathering place for Tempe residents. Key events are scheduled regularly at the adjacent Tempe Beach Park. It's the perfect venue for the Way Out West Oktoberfest (one of Tempe's sister cities is Regensberg, Germany), P. F. Chang's Rock 'n' Roll Marathon, the New Year's Eve Block Party (one of *USA Today*'s top 10 places to spend New Year's Eve), or any number of charitable festivals and 5Ks.

Tempe boasts that it is the place to "Live, Learn, and Work and Play." Historic neighborhoods complement the housing developments that replaced Tempe's farms. Those developments often reflect the names of founding Tempeans. Modern condos offer diversity in the housing stock. Commercial corners anchor neighborhoods. City buildings and parks reflect our settlers' names.

Tempe's schools continue to reflect Tempe's commitment to education. ASU was originally Tempe Normal School and, later, Arizona State Teacher's College. Tempe's employers include the university, a major airline, high-tech companies, financial institutions, and a host of small businesses. Diversity of employers makes Tempe a desirable career hub.

The Tempe that is now home to my grandchildren is very different from the Tempe I knew as a child. I'm very proud to be a Tempean and am thankful for the hand I've had in shaping that change.

Tempe then and now: my hometown.

—The Honorable Harry Mitchell
U.S. Representative

THE RIO SALADO

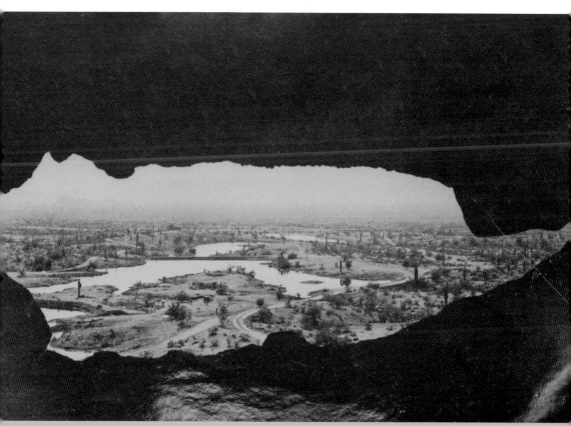

At the end of the Ice Age, the Rio Salado, also known as the Salt River, began weaving its way down from the mountains, braided itself through the valley, and gathered itself into a series of lakes, one of which was just above what is now Tempe, Arizona. Two thousand years ago, Hohokam Indians lived on both sides of that lake.

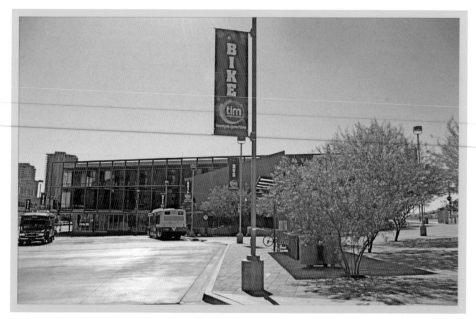

Archaeological digs on the north side of the Salt River have revealed ruins of the Hohokams, such as the Pueblo Grande ruins at the west end of Papago Park, a prehistoric community of pit houses clustered together behind adobe walls. Digs on the south side of the river have revealed Hohokam ruins as well. These sites feature contemporary structures today, however, such as the Tempe Transit Center, shown in the photograph above.

THE RIO SALADO

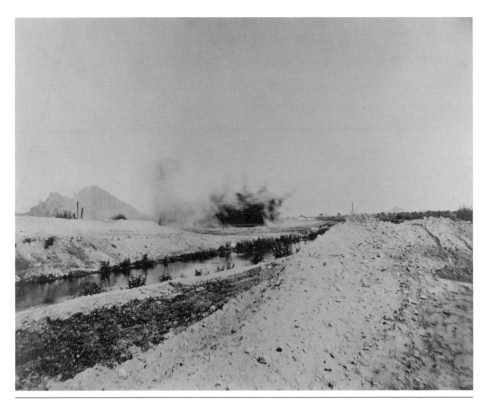

Evidence suggests that the Hohokams were building a system of irrigation canals fed by the Salt River throughout the valley as long ago as 200 AD. Contemporary canals in the Salt River Valley have been patterned after those of the Hohokams. Most of the canals still in service have been covered now and the landscape made almost unrecognizable. This butte now accommodates a luxury hotel, and the surrounding desert now accommodates a baseball stadium.

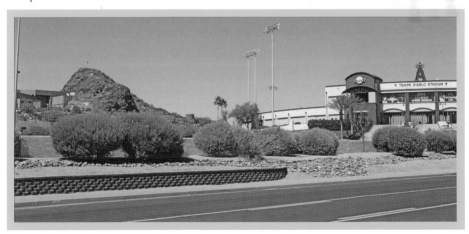

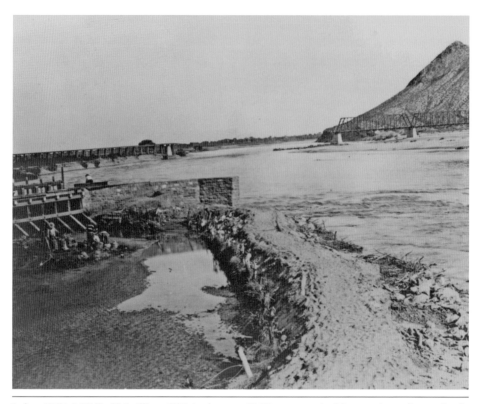

In late 1867, J. W. "Jack" Swilling of Wickenberg, acknowledged as the founder of Phoenix, formed the first canal company to divert water from the north side of the Salt River. By 1871, Charles T. Hayden, William H. Kirkland, and James B. McKinney were building canals on the south side of the river, leading to the founding of the town of Tempe. This ditch on the north side of the river, now part of the LoPiano Habitat area, was recently used to fill Tempe Town Lake.

CHARLES TRUMBULL HAYDEN

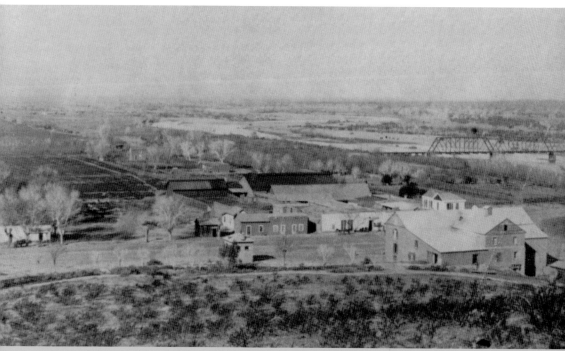

Tucson merchant Charles Hayden first came to the area in 1866, detained on his way to Prescott by the flooded Rio Salado. Climbing the Tempe Butte, Hayden decided this would be a good place to start a business. Soon after, he built a store, a canal to power a flour mill, and a cable ferry across the river and started a town.

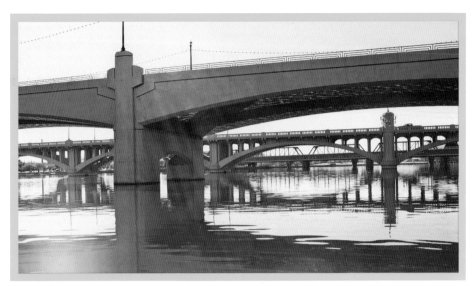

Charles Trumbull Hayden established his ferry on the Salt River in the early 1870s. Today, mere glimpses of the railroad bridge, first built in 1887, can be seen from this vantage point. Blocking the view is the new Metro light rail bridge and Tempe Bridge, built in 1933, which replaced the Ash Avenue bridge, the first highway crossing of the Salt River. Now that major highways have been diverted away from the downtown area, the Tempe Bridge serves local traffic crossing above the new Tempe Town Lake.

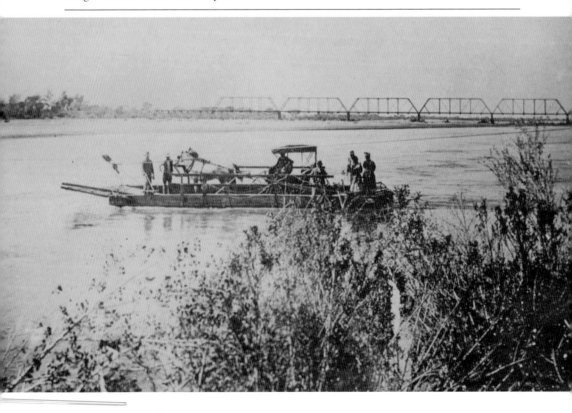

In order to build his canal (the "Hayden Ditch"), clear his land, plant crops, and care for his stock, Hayden hired Hispanic locals—some from families who had been in Arizona for generations—to help him. In return, he planted acres of gardens and orchards to help provide them with food and built row houses with adobe bricks to serve as their shelter.

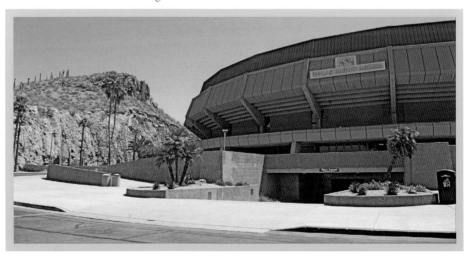

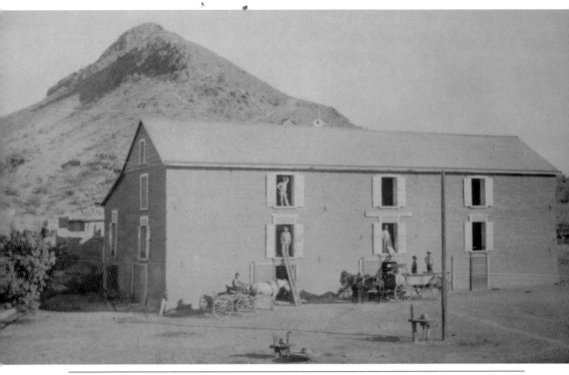

Hayden built his original adobe mill just west of the Tempe Butte soon after he arrived here. By 1874, the mill was in full operation, milling grain from all over the valley and shipping flour to copper mining camps as far away as Globe, Arizona. Around 1885, he added a front section to the mill, which was destroyed by fire in 1890. Rebuilt on the same site, the mill again burned down in 1917. Some of the early walls, however, can still be discerned as part of the more recently built structure.

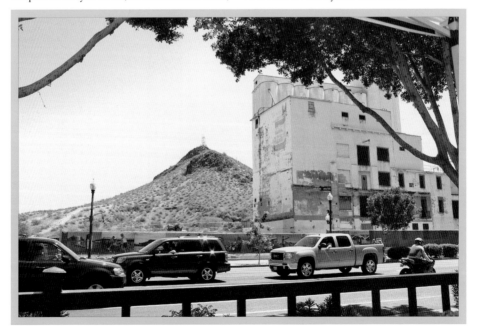

CHARLES TRUMBULL HAYDEN

In 1879, Hayden formed the Hayden Milling and Farming Ditch Company and diverted water from the Salt River into the Hayden Ditch around the butte, the water dropping 24 feet and flowing into the backside of the mill to turn the millstones and grind the wheat into flour. The original grinding stones at the mill were replaced in 1918 by corrugated steel rollers, which were used until the 1980s. The ditch and falls, of course, are no longer here.

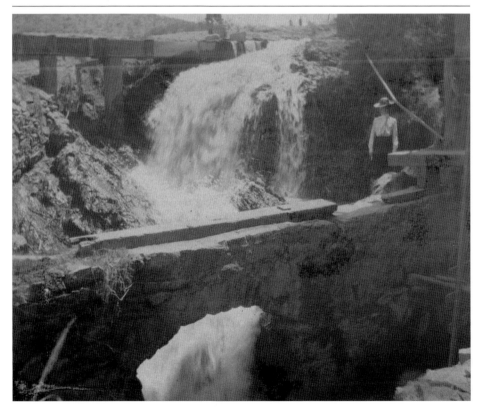

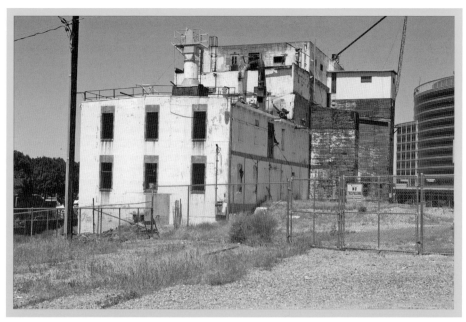

In 1918, the current reinforced concrete structure was built by local contractor J. C. Steele. Later additions included a brick grain warehouse to the west of the mill. In 1951, the concrete grain elevator, with its prominent seven silos, was added to the southeast of the mill. Operated until 1997 by three generations of the Hayden family, the mill still stands on the oldest industrial site in the Salt River Valley, slated for renovation and redevelopment as a hotel complex and shopping center.

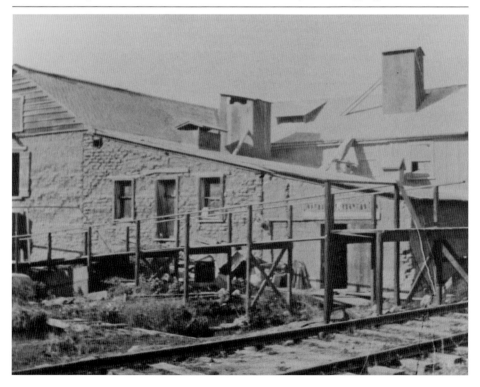

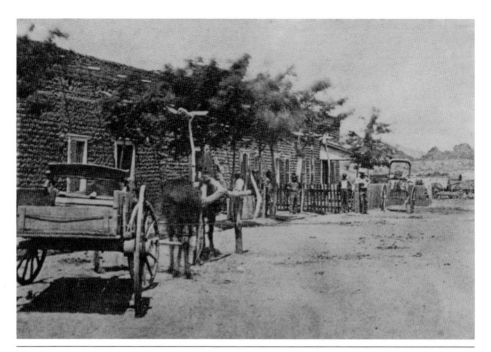

Across the street from the mill was the Hayden residence. Originally built of wattle and daub in 1871, it was replaced by La Casa Vieja, which was built of adobe in 1874. In 1876, Charles Hayden married Sallie Davis, who gave birth to son Carl in 1877 in this house. Carl T. Hayden served in the U.S. Senate from 1912 to 1969. La Casa Vieja, with added rooms on the south and west, is now Monti's La Casa Vieja restaurant.

CHARLES TRUMBULL HAYDEN

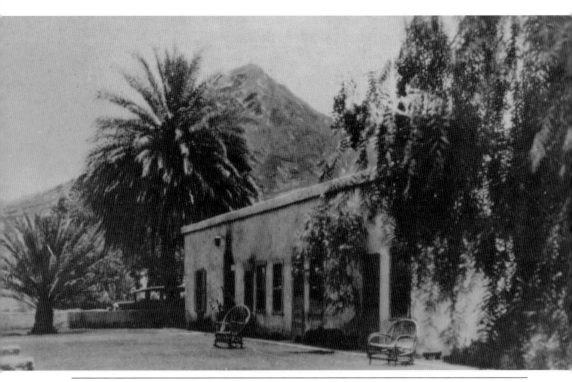

La Casa Vieja has gone through many changes: an L-shaped, Mexican-style adobe row house; a boardinghouse with a frame second story added around 1893; and a restored adobe remodeled as a restaurant with the second story removed in 1924. Restoration of the interior included exposing the cottonwood vigas and willow latillas, as well as bringing back Mexican-style elements, such as the wrought iron light fixtures. The north side of the old house is now the main entrance to Monti's.

CHARLES TRUMBULL HAYDEN

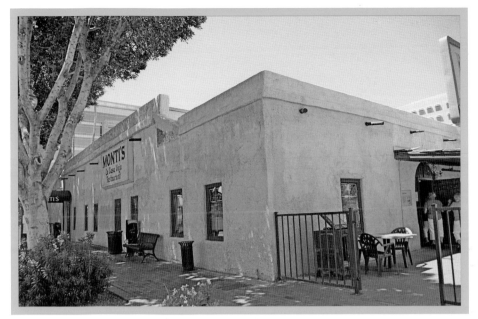

By 1876, two additions had been made to the original Hayden house, an entry and a 20-foot square room next to it. By 1889, a second story was added above the entry and two rooms on the first floor to the west, but by that time, the Haydens had moved to a ranch east of town near present-day McClintock and University Drives. From 1890 to 1924, when the upper story was removed, the Hayden house became a boardinghouse.

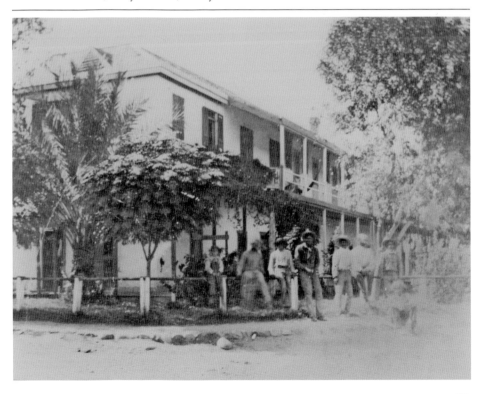

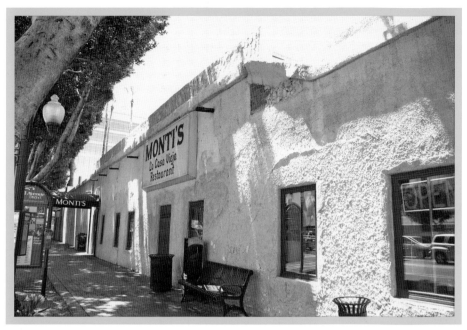

Hayden's first store was simply a ramada roofed with a tarp where he sold merchandise from his business in Tucson. With the building of his adobe store located on the west side of what is now Mill Avenue (just north of La Casa Vieja) in 1871, his business expanded to include a carpentry shop, a blacksmith shop, and, in 1872, a post office. Today this section of building is also part of Monti's.

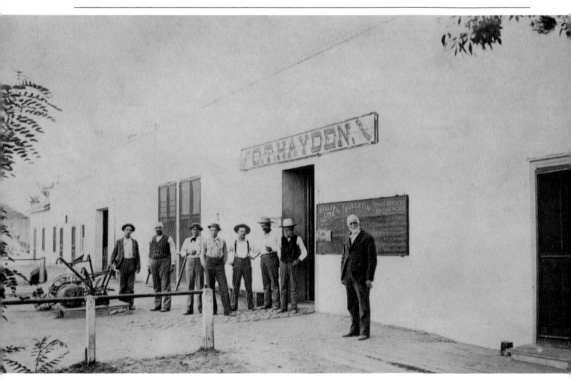

CHAPTER

EARLY TEMPE ENTERPRISES

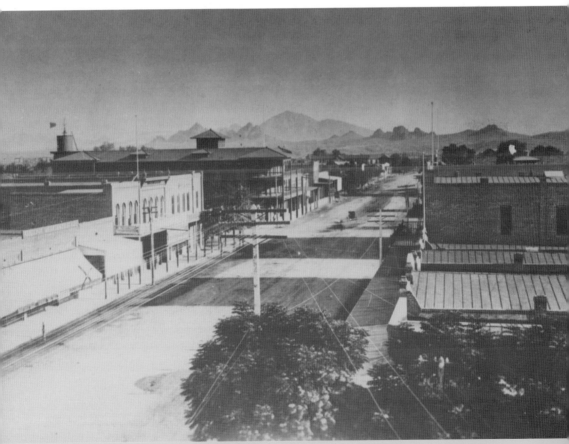

By 1872, a cable ferry built by Hayden was also in operation, resulting in the town being named after it. Soon after, Hayden's Ferry was populated by mill workers, carpenters, blacksmiths, hostlers, butchers, bakers, and various other merchandisers, as well as outlying farmers and ranchers who provided the essential goods.

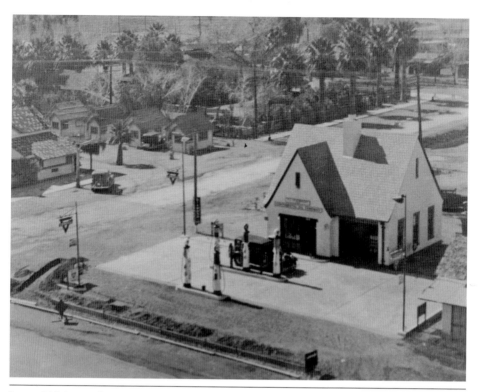

Just up Mill Avenue from La Casa Vieja and on the same side of the street (on the northwest corner of South Mill Avenue and Second Street) was once located Pendleton's Service Station, shown here around 1930. Though this site is now a parking lot, the southwest corner of Mill Avenue and Second Street is dominated by a brand-new office and commercial building.

During the 1950s, just up Mill Avenue from the Hayden Mill granaries (shown in the background), at 211 South Mill Avenue was Dana Brothers Motor Company, sales office for Chrysler Dodge new and used cars and a full-service gas station. This site is also now a parking lot adjacent to Tempe's new light rail line.

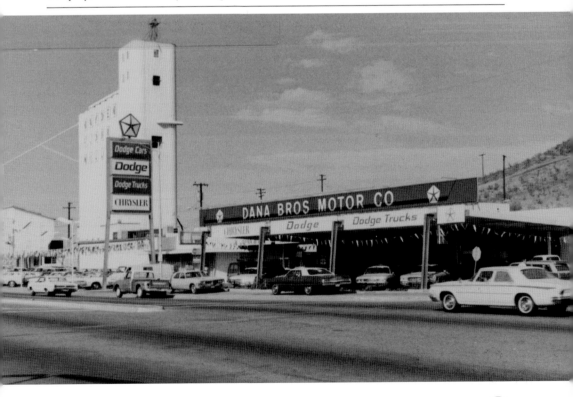

At 401 South Mill Avenue is the Andre building, built by saddle maker R. G. Andre in 1888. Destroyed by fire in 1889, this territorial commercial structure with elements of Victorian and neoclassical architecture was rebuilt by Andre in 1900. Owned by the C. G. Jones family from 1912 to 1977, this building once housed Andre's original hardware and harness shop, a furniture store, a mortuary, a newspaper, a post office, and a Masonic lodge.

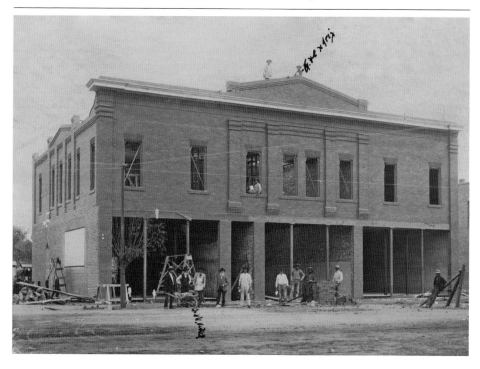

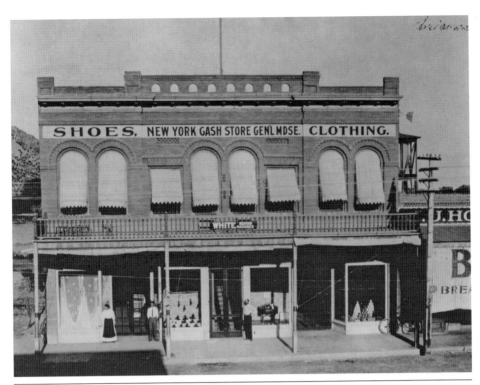

At 409 South Mill Avenue was the Peterson building, built by cattle rancher Niels Petersen in 1898. During the Spanish-American War, a second story was added to this building, which became an armory for the Arizona National Guard. Businesses located here included a dry goods store and a post office. In 1927, the building was remodeled and the second floor converted to apartments. In 1933, the building was further rehabilitated.

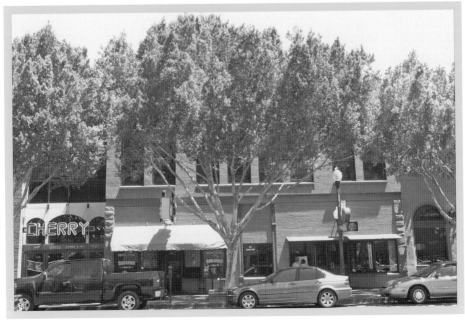

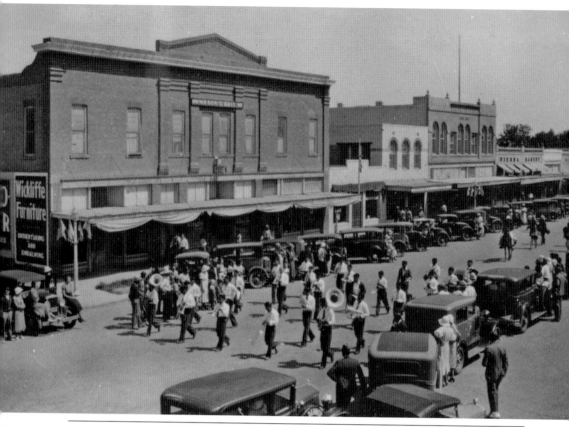

Both the Andre and Petersen buildings can be seen in this 1931 photograph of a parade down South Mill Avenue. Today the Andre building houses a restaurant and sports accessories outlet. The Petersen building is a replica of the original structure, which was destroyed by fire in 1990, and now houses two more restaurants. At far right in this photograph is the old Vienna Bakery, the site of which is now occupied by yet another restaurant.

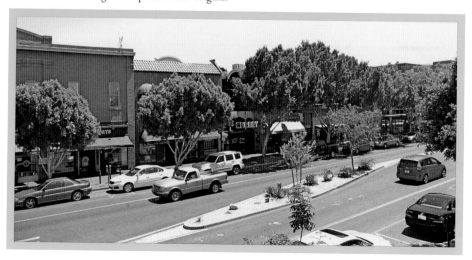

The Vienna Bakery building at 415 South Mill Avenue, home of a bakery run by German immigrant Charles Bauer from 1904 until 1963, was built by John S. Armstrong in 1893. Armstrong was a member of the territorial legislature and former Tempe postmaster. First housing a drugstore, then hardware, mortuary, and post office, this Spanish Colonial Revival style building was originally a Victorian.

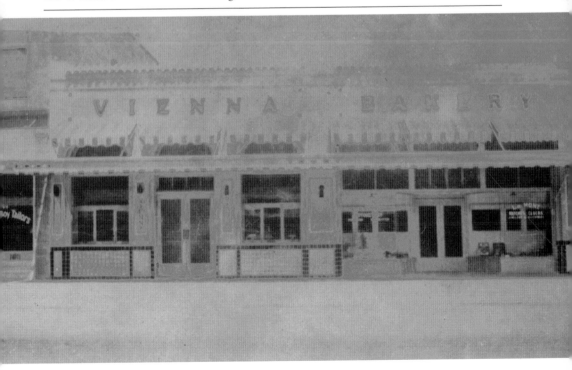

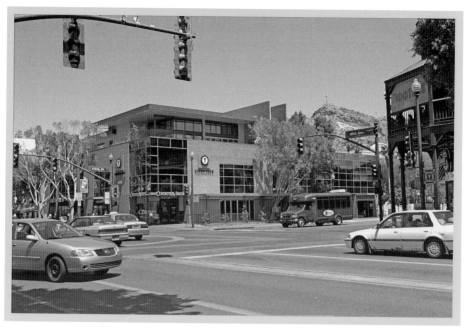

At 410 South Mill Avenue was the Tempe Market, and next to that, on the northeast corner of Fifth Street and South Mill, was the Calapco building, the main office for Tempe's electric company. The Tempe Market was later joined by another grocery store, Tempe Market II, on the northwest corner of Ash Avenue and University Drive and built by the same owner, Charles Ecklor. The Calapco building later became the office for Arizona Public Service. Now this corner is occupied by a bank.

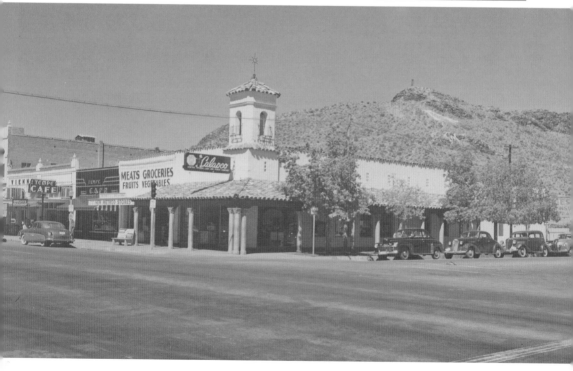

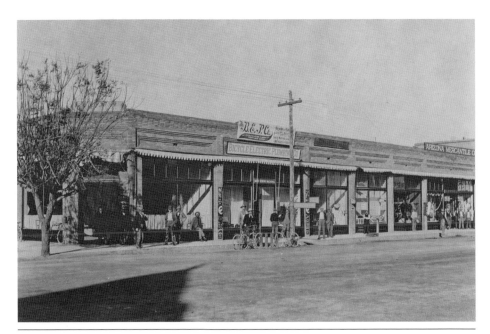

Across the street at 418 South Mill Avenue was the Miller Block building, part of the first completely occupied commercial block in Tempe. It was built by local rancher and entrepreneur Albert Miller in 1900. Continuously occupied until it was demolished in 1998, this building housed businesses associated with the Arizona Mercantile Company, a grocery store, and various other enterprises. Now this corner is occupied by a two-story building that houses a microbrewery, coffee shop, offices, and restaurants.

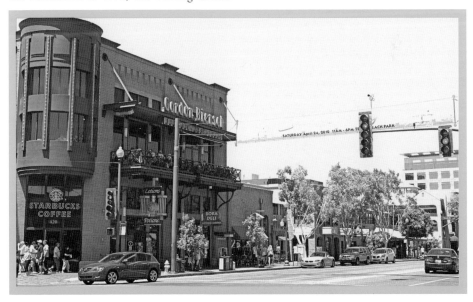

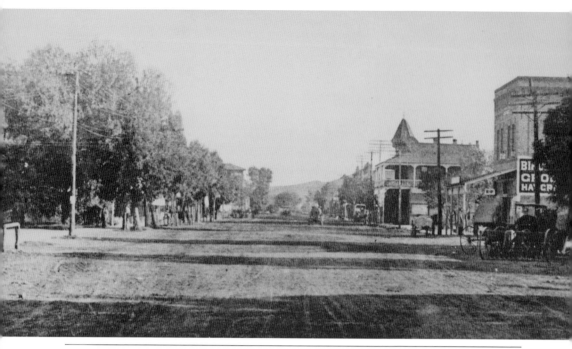

Looking north from Fifth Street down Mill Avenue, on the southeast corner of Fourth and Mill can be seen the old Casa Loma Hotel. Replacing the Tempe Hotel, which was destroyed by fire in 1894, the Casa Loma, as shown here, had undergone a recent face-lift and added a third floor. Today, of course, this view observed from the old Laird and Dines building has changed drastically.

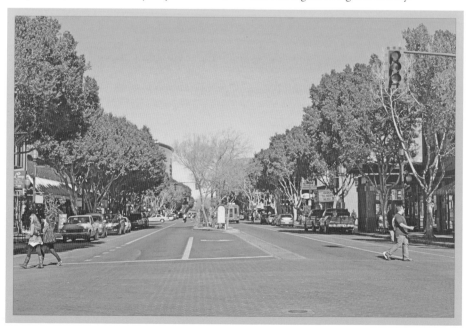

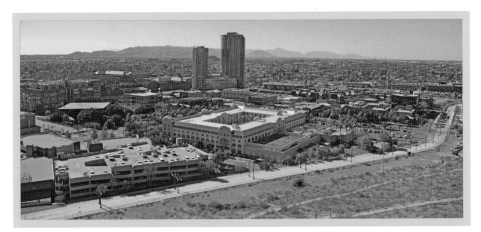

Looking south and west from Tempe Butte, the Laird and Dines Drugstore on the southeast corner of Mill Avenue and Fifth Street can be seen. It was built in 1893 and is now part of a restaurant and nightclub complex. Across Mill Avenue is the Tempe Hardware building, built in 1898 and still standing, housing various enterprises. The empty lot on Fifth Street in the foreground is now the location of the Mission Palms Hotel.

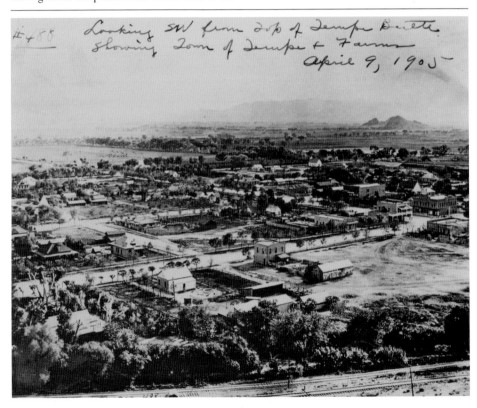

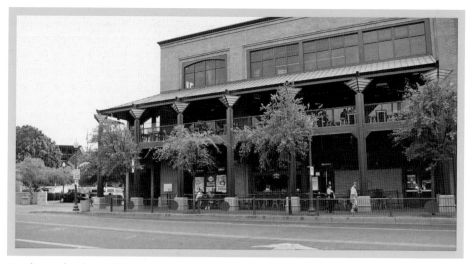

On the south side of Fifth Street—part of the restaurant and nightclub complex, just west of present-day city hall—was the old State movie theater, shown here around 1933. The State was the first theater to feature talkies in Tempe. Around the corner on Mill Avenue is the Harkins Theater, originally located near the southwest end of the Tempe Bridge and known as the Tempe Beach Theater. The Tempe Beach Theater was the first of the Harkins theaters, founded by Dwight "Red" Harkins.

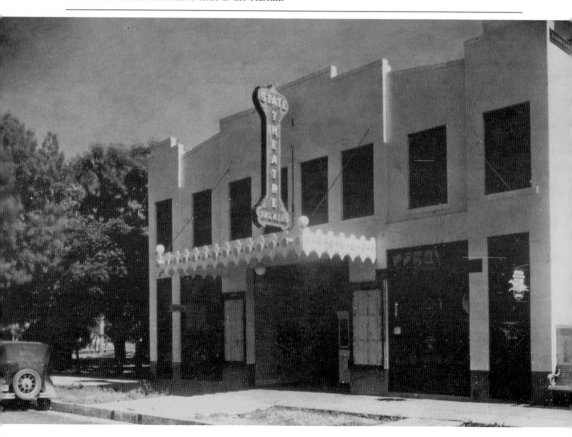

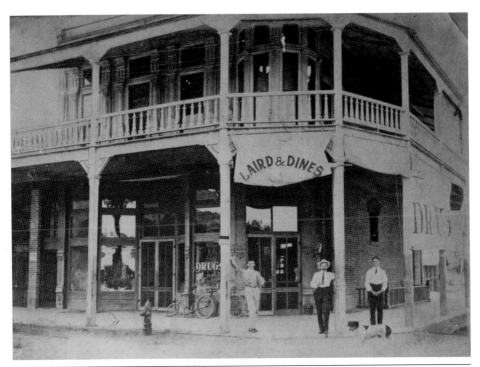

The Laird and Dines building at 501 South Mill Avenue was built by L. A. Amirault for Dr. S. C. Heineman and R. Gill in 1893. Dr. James A. Dines, Hugh Laird, and his brothers, William and Claude Laird, took over the drugstore in 1897 and continued in business until 1960. Both J. A. Dines and Hugh Laird were Tempe city councilmen (Dines serving for 20 years), and both were mayors (Dines for several terms). Hugh Laird went on to become a member of the state legislature.

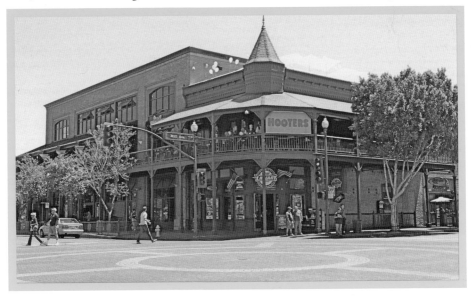

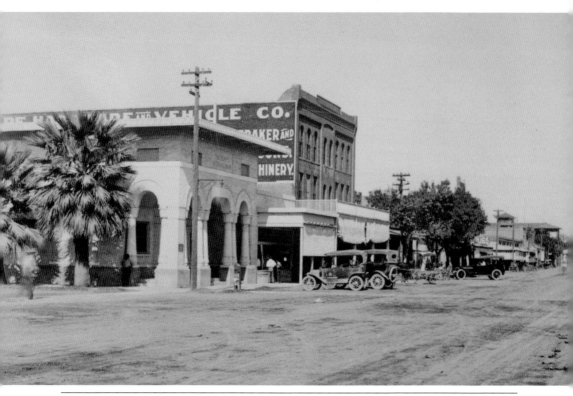

The Tempe Hardware at 520 South Mill Avenue—the oldest three-story brick commercial building in Maricopa County—was built in 1898. First occupied by the Odd Fellows and sporting a two-story high ballroom on the second floor, this building hosted several fraternal organizations and the Tempe City Council and served as a meeting hall for Tempe's first Mormon congregation. From 1906 until 1976, this building was occupied by the Curry family hardware store.

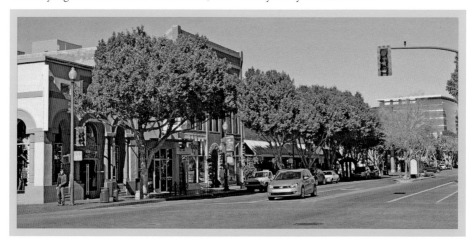

Next to the Tempe Hardware building, on the southwest corner of Sixth Street and South Mill Avenue, is the Tempe National Bank building. The Tempe Hardware building, rehabilitated in 1982, is now occupied by a beauty salon and a clothing store. The Tempe National Bank building also is occupied by a clothing store. Looming in the background is a new 33-story housing and office complex.

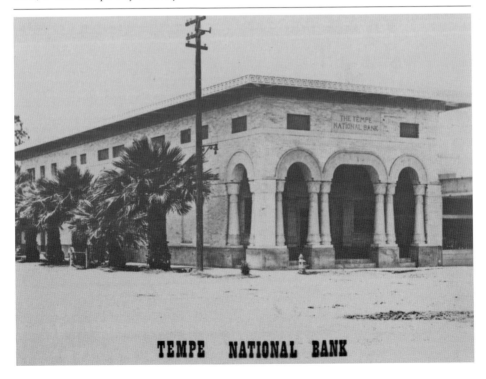

TEMPE NATIONAL BANK

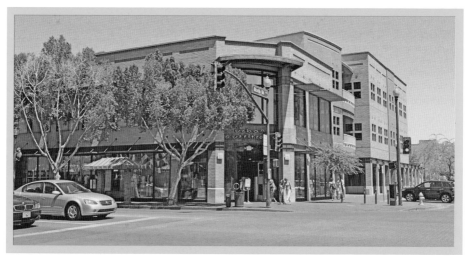

The Birchett Brothers grocery store, later the Barber Jones Mercantile Company building, was located on the northeast corner of Sixth Street and Mill Avenue. Joseph T. Birchett, a partner in the grocery, was a director of the Tempe National Bank across the street and a former mayor of Tempe. Birchett and his wife, Guess Birchett, lived in a house at 202 East Seventh Street, just around the corner and a block away from the grocery. Unfortunately, there are no more corner groceries in downtown Tempe.

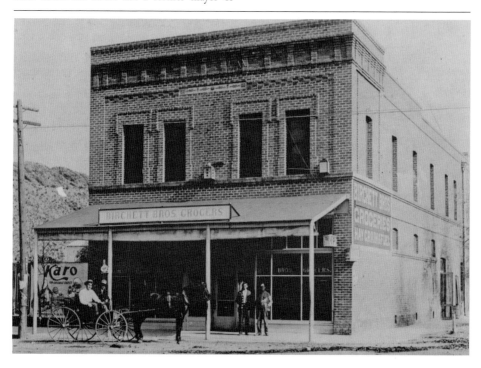

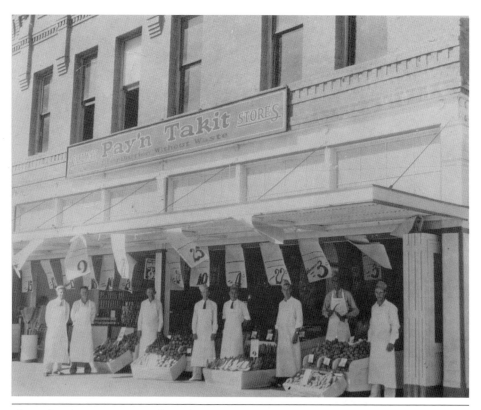

The Pay'n Takit grocery store, formerly located at 730 South Mill Avenue (now demolished), was built in 1927. D. J. Peter and George W. Mickle founded this cash-and-carry chain in Phoenix in 1917. After merging with Safeway in 1928, the chain became known as the Safeway Pay'n Takit. The Rundle family took over the store some time after 1940 and renamed it Rundle's Market. Today Rundle's Market has gone the same way as Birchett's grocery.

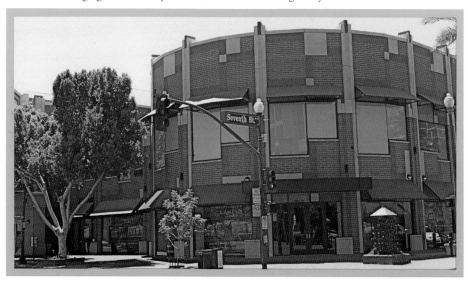

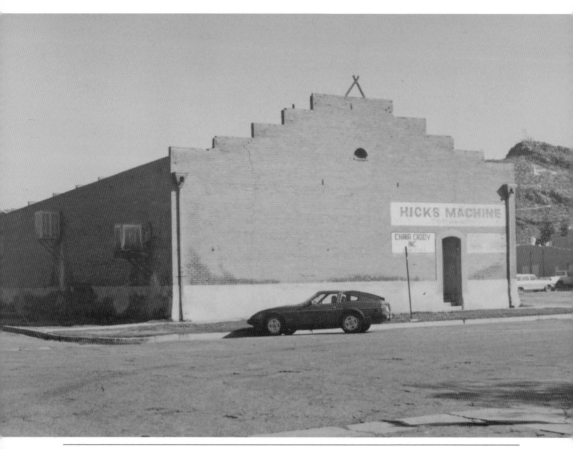

Before being destroyed by fire in the mid-1980s, the Ellingson Grain Warehouse at 24 West Seventh Street, built in 1909, was the oldest remaining brick warehouse in Tempe. Local farmer and rancher Mons Ellingson operated his grain and seed business out of this warehouse until 1921. Subsequently, the building continued to be used as an arsenal, storehouse, and machine shop.

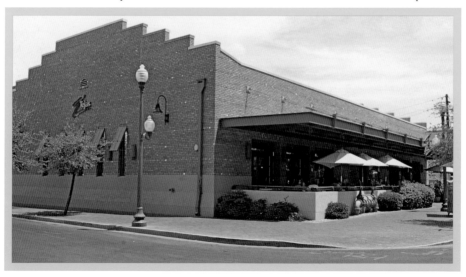

EARLY TEMPE ENTERPRISES

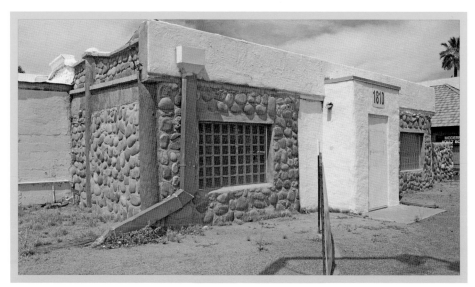

At 1810 Apache Boulevard was the dairy farm of E. M. White, who built this barn from river cobble some time around 1919. White had previously bought the property from M. H. Mayer and J. H. Guyer and utilized it as a dairy farm until subdividing it into one-acre tracts in 1927. After 1930, the barn was converted for use by commercial enterprises, in this instance as an Irish pub. Today, the pub is gone, but the building still remains.

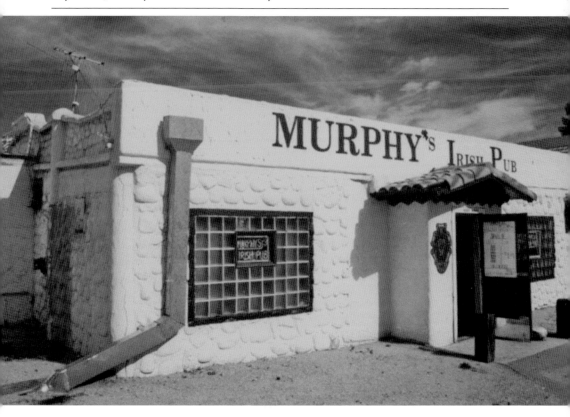

The Pacific Creamery complex at 1350 University Drive was built in 1892. First known as F.A. Hough's ice plant and then the Tempe Creamery, the plant was taken over in 1907 by the Pacific Creamery under the management of Justin B. Cook. In 1927, the creamery was bought by the Borden Company, which remodeled the building and operated the business until 1953. Between 1954 and the 1960s, Arden Farms operated the business. Currently, the complex houses a microbrewery.

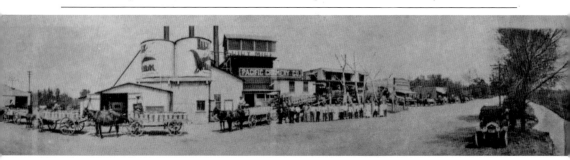

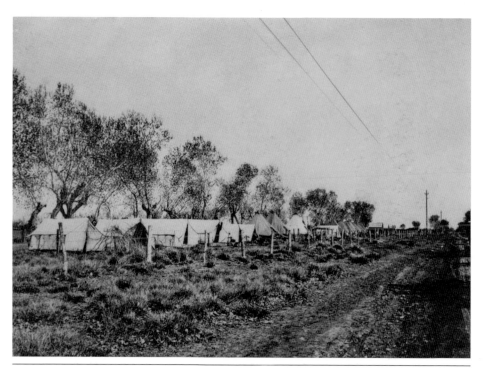

On the outskirts of downtown were a number of farms and ranches. At Southern Avenue and Rural Road was the Hudson Cotton Camp—temporary housing for workers in the cotton fields. From 1916 to 1920, the Salt River Valley experienced a cotton boom, becoming a major supplier of long staple cotton, a variety with greater tensile strength than shorter staple cotton. No cotton fields remain, however. This particular site is now occupied by the city of Tempe's cultural and recreation departments.

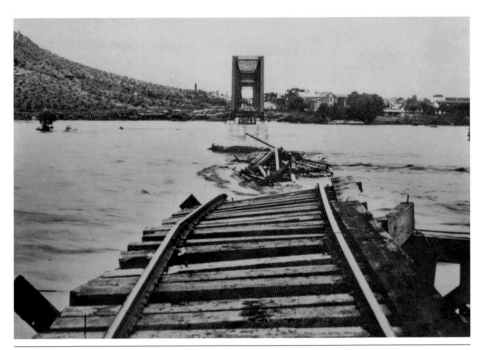

Except during the times when the railroad bridge was washed out, the railroad was the major mode for shipping goods in and out of Tempe. Both the first bridge, built in 1887, and second bridge were washed out by floods, the second bridge during the flood of 1905 (shown here).

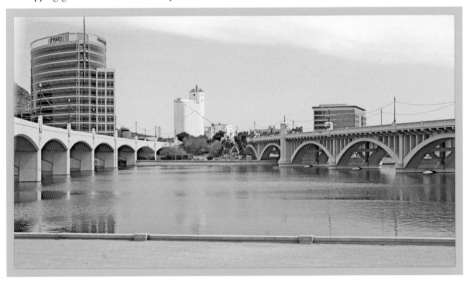

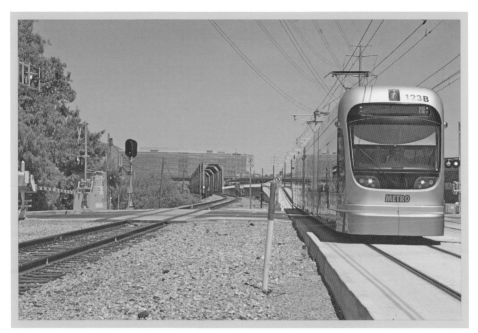

The present Union Pacific Railroad Bridge was built by the Arizona Eastern Railroad in 1913 and has survived every flood since. The original Tempe railroad depot first served the Phoenix and Maricopa Railroad and then the Arizona Eastern Railroad. The two merged in 1910. Though the railroad bridge remains (shown here in background), the site of the original depot is now occupied by another building, hidden by the new light rail.

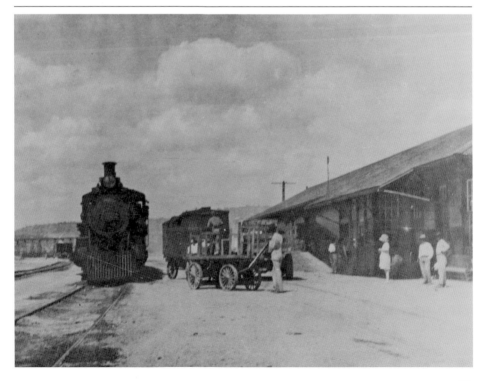

The present depot building (shown in this photograph) was built in 1924 and used by the Southern Pacific Main Line until 1925. Now part of the Union Pacific Railroad, the train no longer stops here. The old depot remains in use, however, remodeled as a restaurant and sports bar accessible from Ash Avenue.

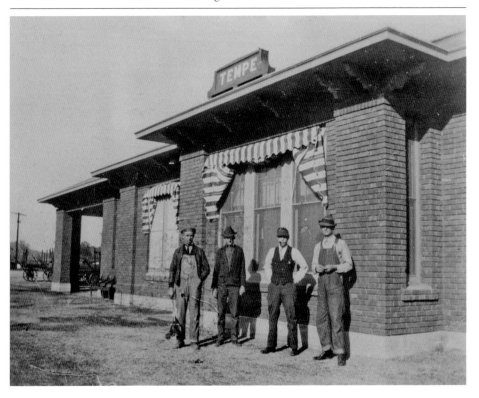

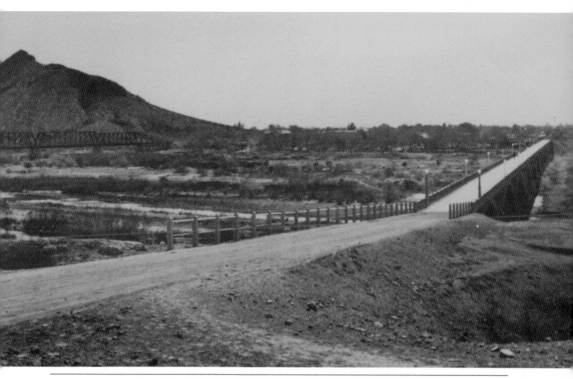

The other major modes of transportation were highways. The Ash Avenue bridge, built in 1913, was the first highway bridge to cross the Salt River. Weakened by the flood of 1916, the Ash Avenue bridge was closed to all but pedestrian traffic and replaced by the Mill Avenue bridge, or Tempe Bridge, in 1931 and finally demolished in 1991. Part of the bridge, however, still remains at the foot of Ash Avenue today, on the west side of the Tempe Town Park.

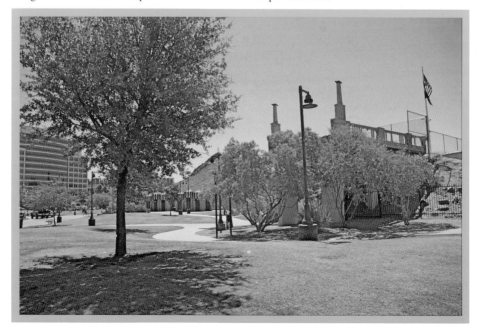

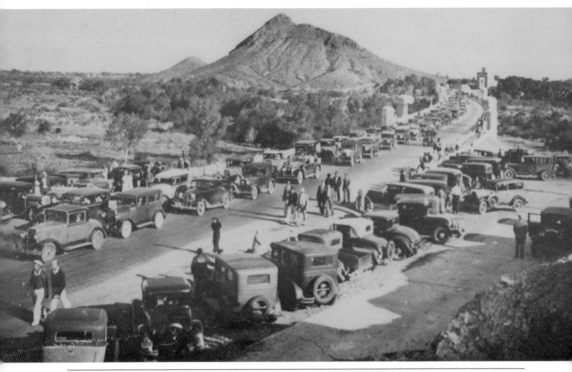

The Tempe Bridge dedication (shown here) took place after it was finished in 1933. The oldest crossing of the Salt River in Phoenix still surviving, the Tempe Bridge was the major link for U.S. 60, 70, 80 and the only north/south crossing for U.S. 89 until the interstate system was created in the 1950s. Even today, the Tempe Bridge—now one way south, joined by another new span, which is one way north—remains one of the major crossings when other highways are closed due to flooding.

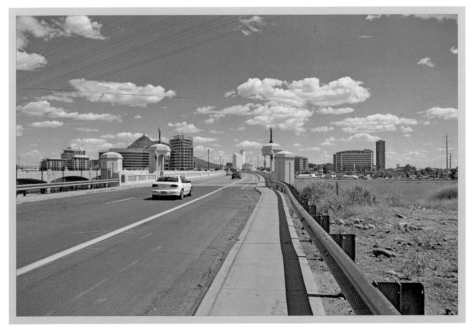

4

RESIDENCES, CHURCHES, AND SCHOOLS

By the time the Phoenix and Maricopa Railroad arrived in 1887, Tempe, as the town was then known, was booming. Various business enterprises, houses, churches, and schools fanned out from the foot of Hayden's Butte. At the very base of the butte on the western branch of the Kirkland McKinney ditch was the earliest residential community in the area, known as San Pablo—a thriving community of Hispanic families living in typical adobe homes.

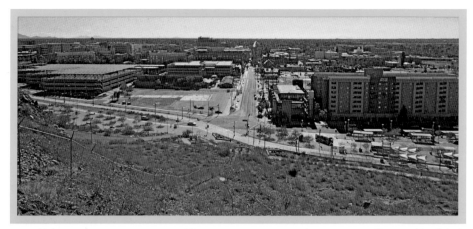

San Pablo—occupying 80 acres situated between present-day College Avenue, Rural Road, and University Drive—was donated to Hispanics who worked the ditches for James McKinney in 1872. McKinney and his partner, William Kirkland, built the first irrigation ditch on the south side of the Salt River. Since the mid-1950s, this site has become the main campus of Arizona State University.

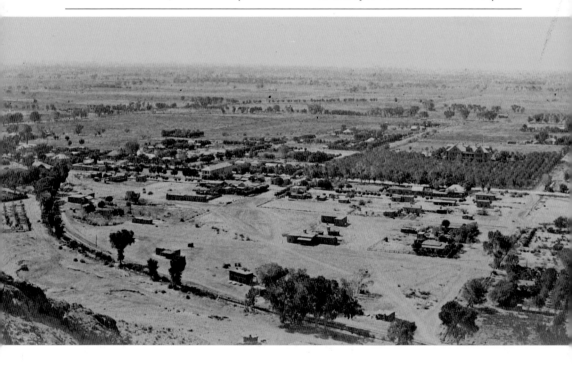

RESIDENCES, CHURCHES, AND SCHOOLS

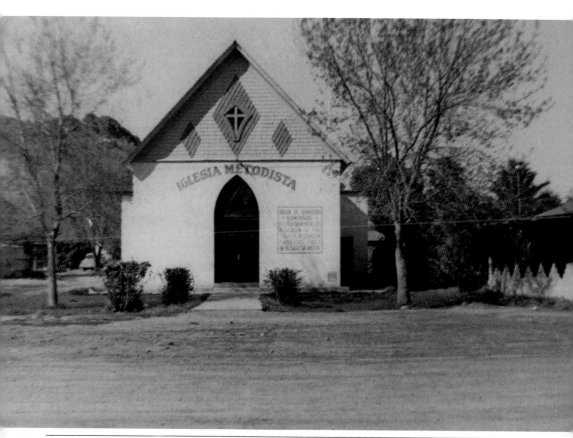

The Iglesia Metodista was built in San Pablo to serve the Hispanic community some time around 1896. Now this site is occupied by the Palo Verde dormitory at ASU. After ASU purchased the land in and around San Pablo, including acreage south of University Drive and east to Rural Road, many of the Hispanic residents moved to Victory Acres, a new subdivision between University Drive and Apache Boulevard and east of Price Road.

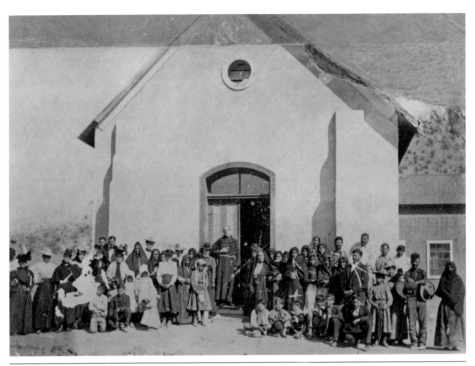

The first church in Tempe, Our Lady of Mount Carmel, was built in the saddle on the butte in 1892. Now this site has become the college football stadium, home of the ASU Sun Devils. Sun Devil Stadium (built in 1958) replaced the old Goodwin Stadium on College Avenue and Apache Boulevard and was later appended with the name "Frank Kush Field" after ASU coach Frank Kush.

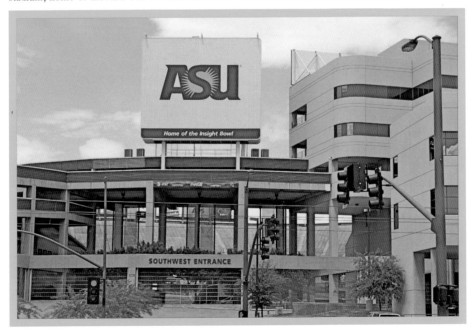

RESIDENCES, CHURCHES, AND SCHOOLS

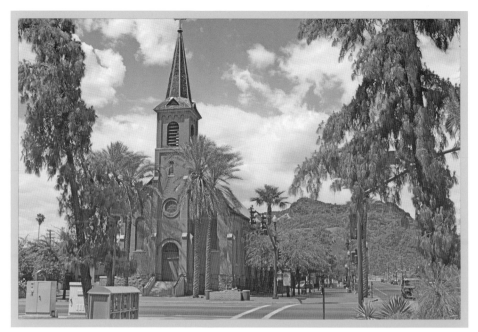

A new Catholic church, St. Mary's Catholic Church, was built on the northwest corner of present-day College Avenue and University Drive in 1903. Constructed of locally made, fired red brick, St. Mary's is a significant example of territorial Victorian Romanesque Revival architecture. Remodeled by the Knights of Columbus in 1976, the church building is now the chief edifice of the Catholic Newman Center at Arizona State University.

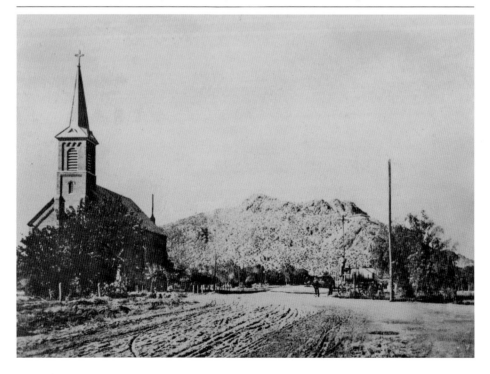

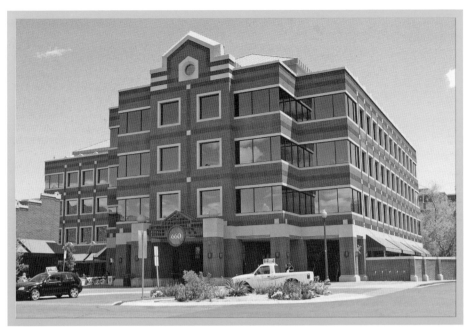

Among other churches in the downtown area were the North Methodist Episcopal Church, built in 1888 on Maple Avenue and Sixth Street, and the South Methodist Church on Ash Avenue and University Drive, built in 1890 (shown here). The difference between the congregations of the two churches had to do with opposing views on slavery during the Civil War. The loss of its minister at South Methodist precipitated a move toward conciliation between the two congregations. This site is now occupied by the Center Point office building.

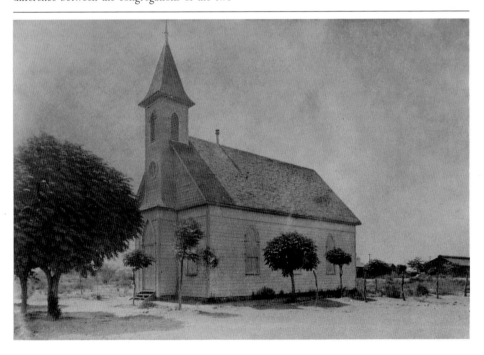

RESIDENCES, CHURCHES, AND SCHOOLS

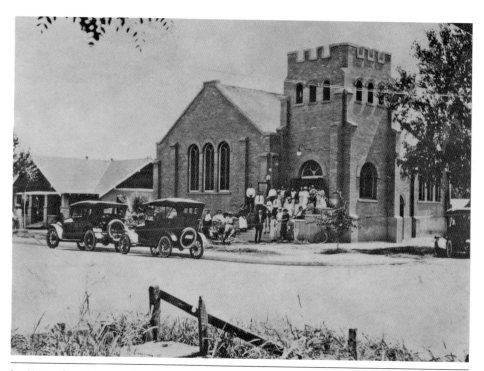

In 1914, after the two churches united, Niels Petersen donated land and money to erect a new church building on Forest Avenue and University Drive. The parsonage across the street from the Methodist Episcopal church at 718 South Maple Avenue (left of the church) was also built in 1914. This single-story, painted brick house was dismantled and reconstructed at Old Town Square, 150 South Ash Street, an office complex consisting of five historic homes. The former site of the church is now a movie theater complex.

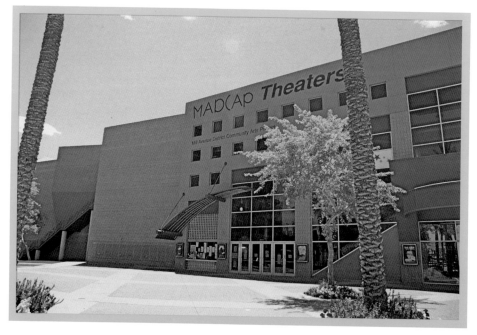

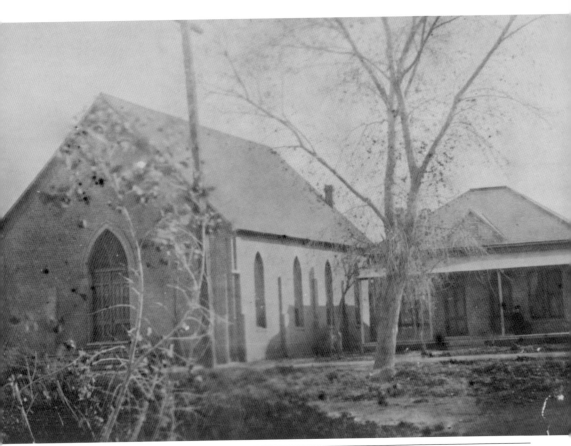

The Congregational church on Myrtle Avenue and East Sixth Street, now replaced by a modern building, and the First Baptist Church on Myrtle Avenue and University Drive (shown here) were both built in 1899. Thomas M. Pyle, father of John Howard Pyle, was the minister at First Baptist from 1925 to 1930. John Howard Pyle, who married Lucille Hanna and built a house on Ash Avenue in 1930, was governor of Arizona from 1950 to 1954. The First Baptist Church building is the home of the Tempe Salvation Army.

RESIDENCES, CHURCHES, AND SCHOOLS

The first school in the Tempe school district was the one-room Kyrene School on the northwest corner of McClintock Drive and Warner Drive, built in 1888. Destroyed in a windstorm, it was replaced by another one-room frame schoolhouse in 1890. The Eighth Street School on the corner of University Drive and Mill Avenue, shown here around 1895, was much larger and more substantial, having been built with brick. Modern school buildings scattered throughout Tempe have replaced these old structures. Former sites have been put to other uses.

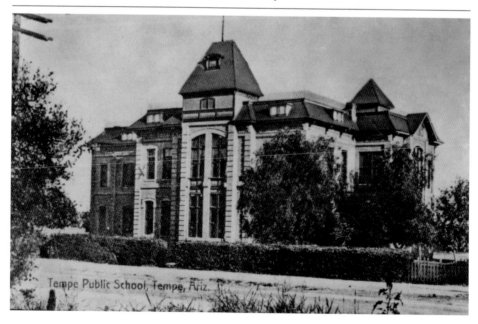

Tempe Public School, Tempe, Ariz.

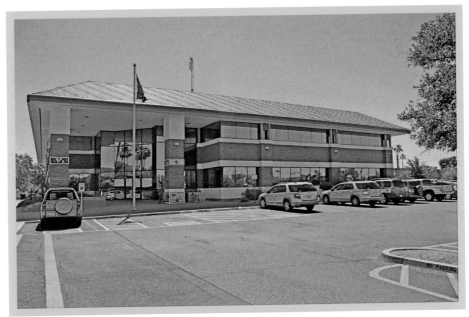

Rural School, on Rural Road and Southern Avenue, was demolished and is now the site of the district office for Tempe elementary schools. The Tempe Grammar School, on the corner of Tenth Street and Mill Avenue (shown after a snowstorm in 1937), was destroyed by fire and is now the site of a business block.

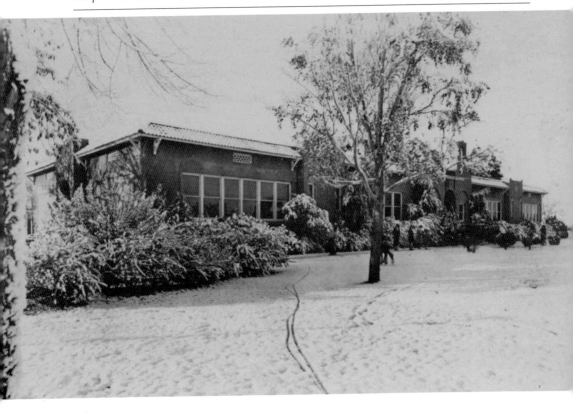

RESIDENCES, CHURCHES, AND SCHOOLS

On the south edge of downtown Tempe, formerly at Myrtle Avenue and East Tenth Street, was the Tenth Street School, built in 1915. The first principal of the school was Sidney B. Moeur, who later became an instructor at the Tempe Normal School, now Arizona State University. In 1958, the university bought this Spanish Colonial structure, renaming it after education professor Dr. Ira D. Payne and making it a classroom building for students in education and theater. Now it is known as Fulton Hall.

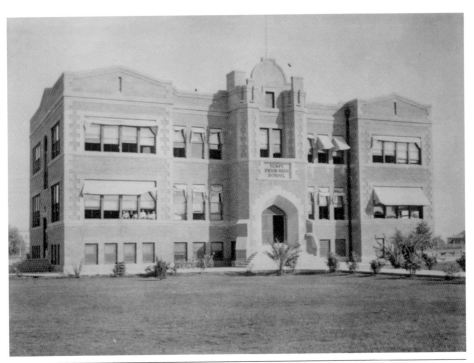

Tempe Union High School, on the east side of Mill Avenue between Ninth Street and University Drive, was built in 1909. This building burned in 1955. A year and a half later, the new Tempe high school was built on the northwest corner of Mill Avenue and Broadway Road. The site of the old school was redeveloped as a commercial center and then acquired by Arizona State University. Subsequently, the commercial center was demolished, and the site is being used as a parking lot, pending further redevelopment.

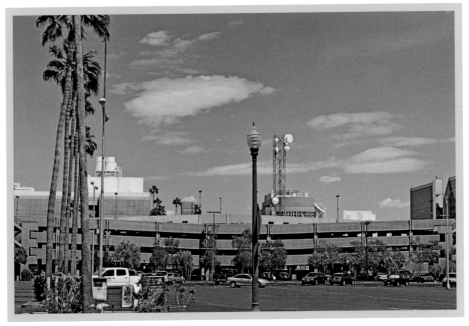

RESIDENCES, CHURCHES, AND SCHOOLS

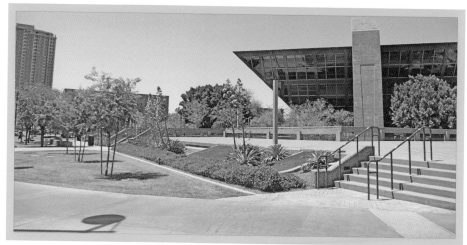

Located at 26 East Sixth Street was the Decker house, built in 1925 and shown in the photograph below. Edwin Decker was the nephew of Susanna Peterson, widow of prominent local farmer and entrepreneur Niels Petersen. Decker built the house for Susanna as a rental. This house was demolished in 1984 and ultimately replaced on an expanded lot by the Tempe City Hall, the building designed as an inverted pyramid shown in the photograph above.

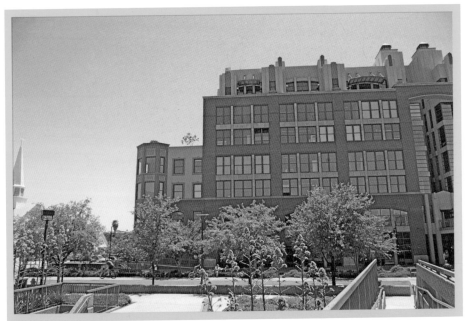

Next door at 29 East Sixth Street and 31 East Sixth Street were two more rentals, built in 1916 by Dr. Benjamin B. Moeur. Both of these buildings were typical one-story brick bungalows with gabled roofs. These buildings were demolished some time around 1984. Moeur came to Tempe in 1896 and served as a representative to the Arizona Constitutional Convention in 1910 and as governor of Arizona from 1933 to 1937. This site is now occupied by the Orchid House condominiums, the building known as "The Brickyard."

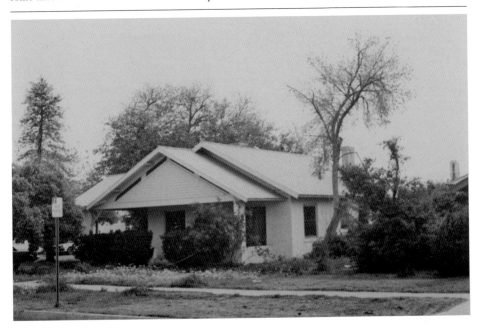

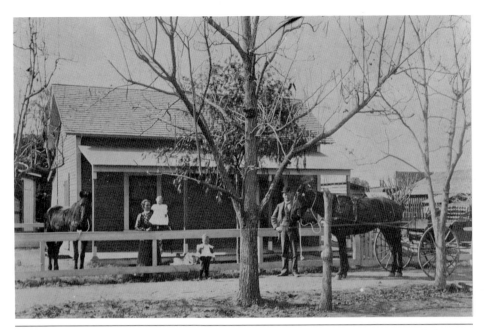

Pictured here are Dr. Moeur and his family in front of the Moeur house on the corner of Myrtle Avenue and Seventh Street. Built in 1892 and still standing, this house was originally a two-room frame cottage. Additions and renovations were made in 1912, 1929, and 1993, giving the house its contemporary appearance. Currently, the Moeur house—now known as Hatton Hall—is utilized by the Tempe Community Council as a place for the community to congregate.

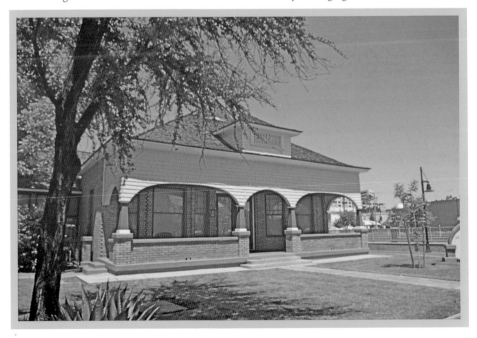

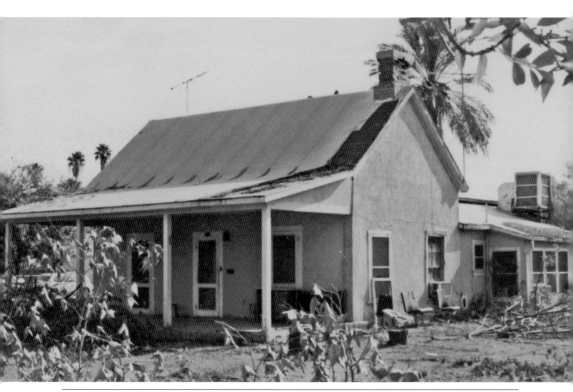

At 125 East Sixth Street stood an adobe house built in 1883 by William C. Park, who lived there until 1887. In 1888, Dr. Fenn J. Hart bought the house after he opened a drugstore in Tempe. Hart was the first mayor of Tempe when the town was incorporated in 1894. Hart continued living in this house until 1919. This house was demolished in 1983. The site is now occupied by the classroom building of the Tempe Islamic Cultural Center.

RESIDENCES, CHURCHES, AND SCHOOLS

The Woolf house, originally on the corner of Myrtle Avenue and Ninth Street, was built by James W. Woolf in 1910. Woolf, a local rancher and former representative to the Arizona territorial congress, built this house of concrete blocks he manufactured at his own plant. In 1915, after Woolf's death, the house was sold to Louis Pinkney Cole. In 1972, the house was dismantled and moved to Olde Town Square. The former site is now occupied by the Lattie Coor building at ASU.

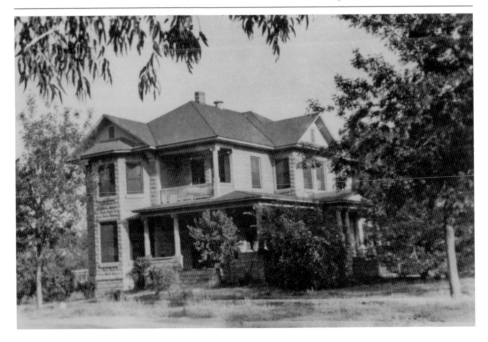

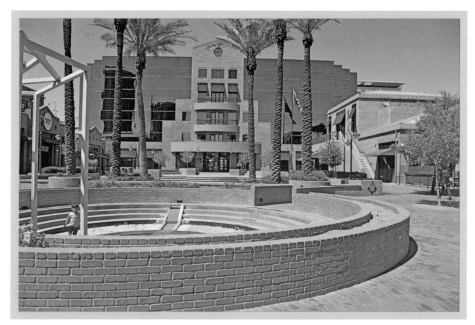

The Curt Miller house at 116 West Fourth Street was built in 1911 by James Woolf and M. H. Meyer. Curt W. Miller was the publisher of the *Tempe News* from 1887 until his death in 1943. He was also a clerk of the Arizona territorial congress, a Tempe postmaster, town clerk, and mayor. This house was demolished in 1983. The former site is at the center of what is now known as Hayden Square.

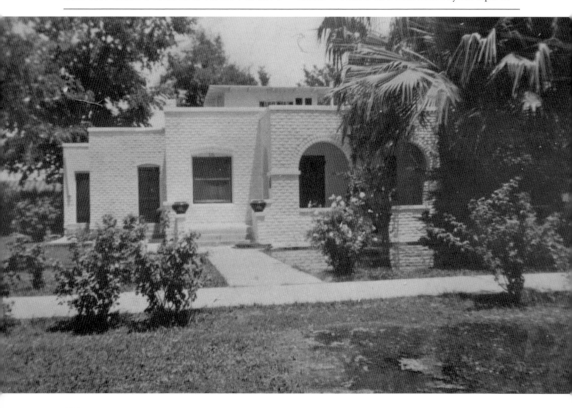

RESIDENCES, CHURCHES, AND SCHOOLS

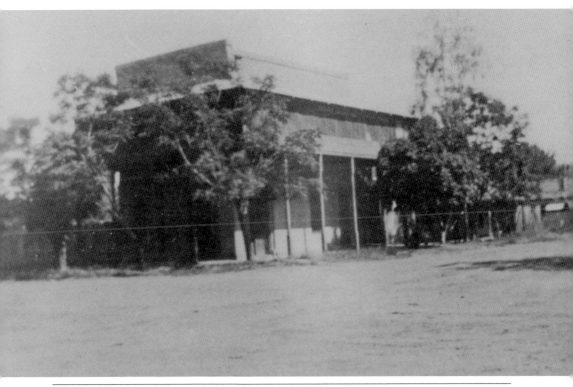

The Hackett house on the corner of Maple Avenue and West Fourth Street, the oldest brick building in Tempe, was built in 1888. First known as the Tempe Bakery and operated by William Hilge, this building became the residence of the Craig family in 1907 and the home of Estelle Craig and her husband, Roy Hackett, until 1974. This building now houses the headquarters of the Tempe Sister Cities programs and cultural exchanges for Tempe's eight sister cities.

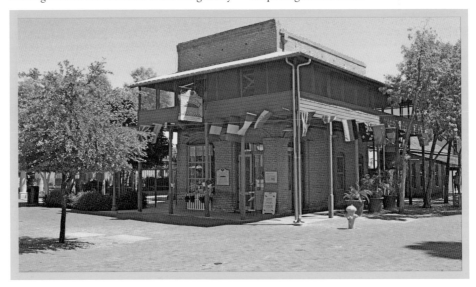

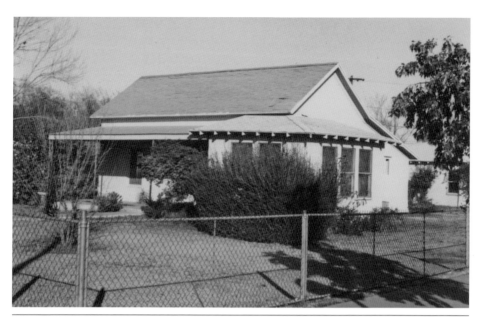

The Openshaw House, formerly at 104 West Sixth Street but now demolished, was built in 1883 by Bishop Samuel Openshaw, the first bishop of the Tempe ward of the Mormon church. Openshaw was forced to leave this adobe house in Tempe because of his polygamist lifestyle in 1885 and, after seeking refuge in Utah, moved to another Mormon community west of Mesa. The site of this house is now dominated by Tempe's tallest residential condominium project (background in the photograph below), currently still under construction.

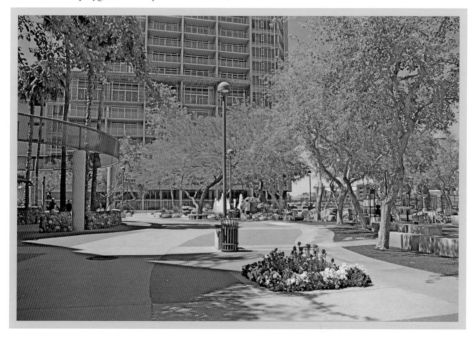

RESIDENCES, CHURCHES, AND SCHOOLS

The Cosner House, formerly at 114 West Seventh Street, was built around 1900 but later demolished. The family of Aaron Cosner, a building contractor who came to Arizona in 1879, lived in this house from 1909 to 1921. In 1921, the house was bought by Loren E. Ensign, one-time city clerk in Tempe. This house was demolished about 1983. The site of this house is now a whimsical park (foreground in the photograph above).

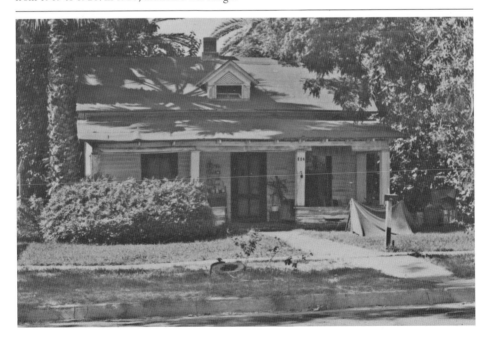

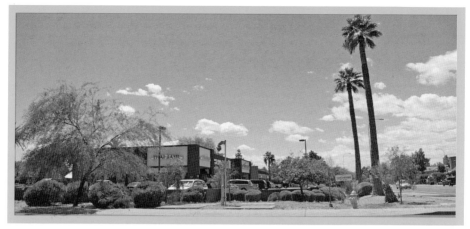

West of Mill Avenue, at 802 South Farmer Avenue, once stood the Murphy house, typical of the building style common during the pioneer settlement days in Tempe. Edward A. Murphy purchased the large agricultural lot on the southwest corner of Farmer Avenue and Eighth Street in December 1887 and built the house in the spring of 1888. Murphy was a local blacksmith and operated the Tempe livery stable until 1900. This house is another historical residence lost to contemporary population growth.

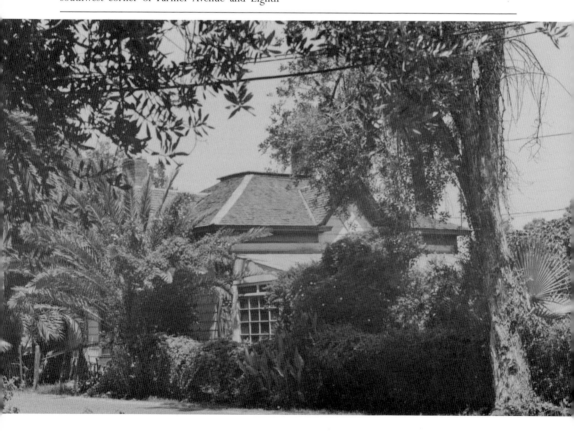

RESIDENCES, CHURCHES, AND SCHOOLS

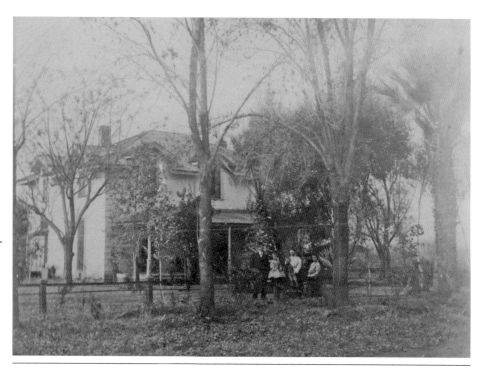

Farther up the street, at 820 South Farmer Avenue, is the Farmer/Goodwin house, still standing. The house was built by local saloon keeper Pierce Carrick Shannon in 1883. In 1886, the house was bought by Hiram Bradford Farmer, first professor and administrator at the Territorial Normal School, now ASU. In 1897, the house was bought by James Wilson, father of Libbie, who married local rancher and businessman James C. Goodwin. The Goodwin family retained ownership of the house until 1992.

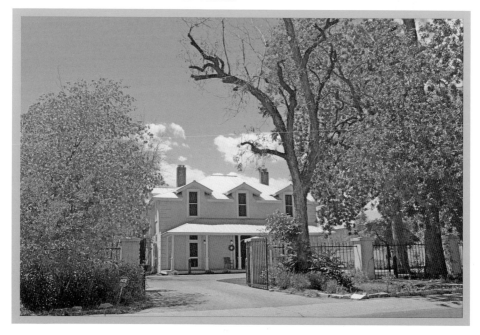

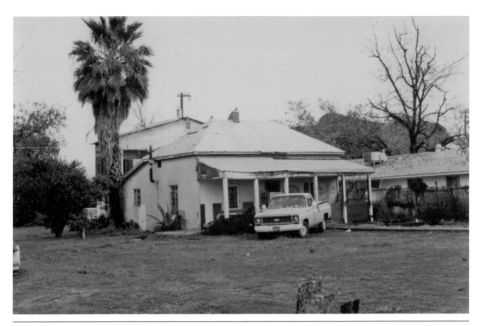

At 108 West University Drive was an 80-acre Mormon settlement divided in 1882 by Benjamin F. Johnson into parcels, each given to four of his six wives. This house was originally a two-room adobe built expressly for Sarah Melissa Johnson, wife number five, in 1883. The house was demolished in 1983. The site of this house is now occupied by the Center Point office building, a major downtown redevelopment project in the late 1980s and early 1990s.

RESIDENCES, CHURCHES, AND SCHOOLS

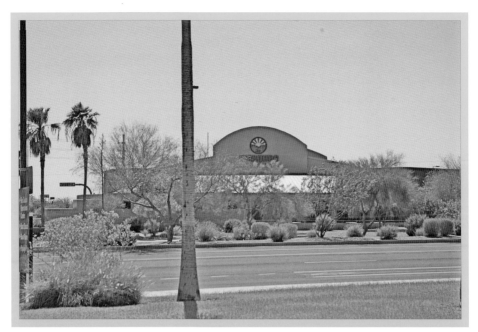

The White House, at 730 North Mill Avenue across the Salt River, was the furthest extension of the Tempe's residential area to the north. Elvin E. White built this house in 1919 on a parcel of land his father had purchased when he moved here from California in 1908. The house was constructed of cobblestone from the Salt River and reinforced with steel railroad rails. Now the house has been replaced by a concert venue, the Marquee Theater.

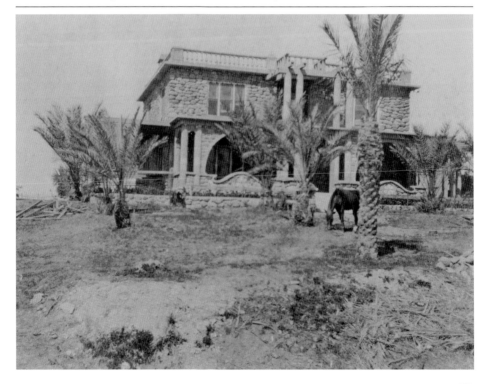

Marlatt's Garage at 1249 East University Drive—on what was then known as the Bankhead National Highway, the main route south through the Salt River Valley—was the furthest extension of Tempe's residential area to the south. Beyond University were only farms and ranches. Built by the Gilliand family in 1922, the garage was owned and operated by Eugene Marlatt from 1933 until 1973 and was the busiest repair shop from here to Tucson. The business is gone, but the building still remains.

RESIDENCES, CHURCHES, AND SCHOOLS

After World War II, George and Mary Tibshraney turned 80 acres of one of those farms into a subdivision known as Victory Acres, named after the victory gardens being tended there. Bounded by University Drive, Apache Boulevard, Price Road, and the Tempe Crosscut Canal, Victory Acres became a close-knit neighborhood of Hispanic families, many of them relocated from the old community of San Pablo. (Courtesy of Tempe Leadership Class VII.)

Now surrounded by more recent subdivisions and cut in half by the 101 expressway, Victory Acres has become known by a new name, Escalante, but still survives. Recent improvements to the neighborhood include the La Victoria Mini-Park, a 4,500-square-foot public space put together by Tempe Leadership Class VII. Working together with the city of Tempe, Maricopa County, and the Salt River Project, the Tempe Leadership class finished the mini-park and canal enhancement project in 1992. (Courtesy of Tempe Leadership Class VII.)

RESIDENCES, CHURCHES, AND SCHOOLS

The Ellingson House at Southern and Mill Avenues was built by farmer and rancher Mons Ellingson. Ellingson built his ranch on Southern and Mill, where he grew grain and alfalfa and grazed his cattle in 1881. He stored his grain downtown at his warehouse on the corner of Sixth Street and Maple Avenue, part of an original complex that housed his grain, feed, and seed business. The warehouse has since been demolished. All four corners at Southern and Mill are now occupied by commercial and business enterprises.

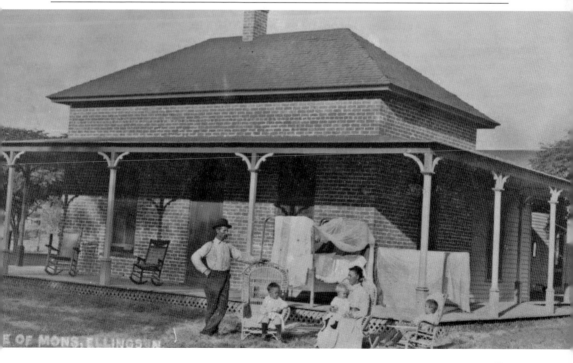

RESIDENCES, CHURCHES, AND SCHOOLS

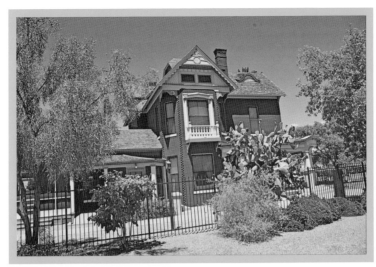

The Petersen house on the northwest corner of Southern Avenue and Priest Drive, the oldest Queen Anne–style brick house in the Salt River Valley, was built by cattle rancher Niels Petersen in 1892. Niels Petersen immigrated here from Denmark in 1871, established his 160-acre ranch between Southern Avenue, Alameda Drive, Priest Drive, and Fifty-second Street in 1874, and eventually became one of the richest men in the Salt River Valley. Fully restored, the Petersen house is now operated as part of the Tempe History Museum.

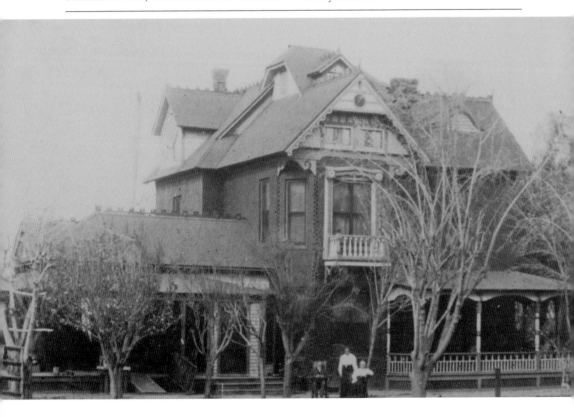

RESIDENCES, CHURCHES, AND SCHOOLS

The main house of the Wetmore Ranch, formerly at Baseline Road and South Forty-eighth Street, was built by Buel Wetmore in 1925. The original frame and stucco bungalow with English cottage features was designed by well-known Phoenix architects Fitzhugh and Byron. The Wetmore family had been farmers in the area since 1913. The house was demolished around 1983 and replaced by a strip mall. The palm trees, however, serve as a kind of reminder.

RESIDENCES, CHURCHES, AND SCHOOLS

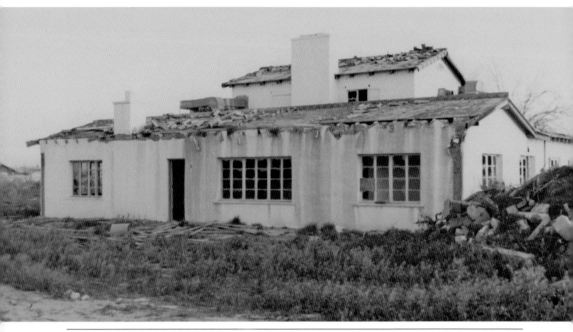

At 545 West Guadalupe Road once stood a Spanish Colonial adobe house built in 1938. For 12 years, this house was occupied by Dr. Dwight G. Hudson, a local dentist, citrus farmer, and cattle rancher. He was the son of E. W. Hudson, who was famous for his development of the long staple cotton typical to the Salt River basin. This house was demolished in January 1983. The original site still remains vacant.

THE TERRITORIAL NORMAL SCHOOL

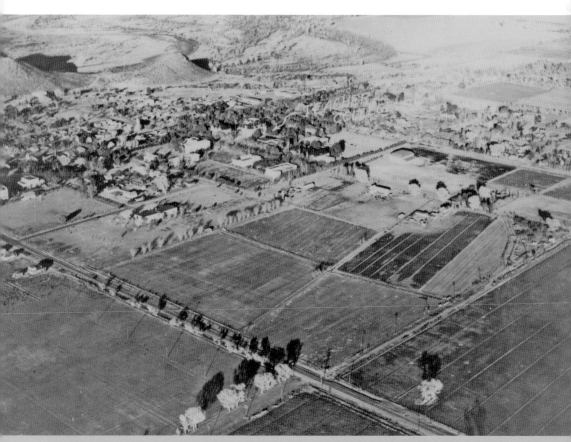

The first college in the territory of Arizona—the Territorial Normal School, now Arizona State University—was established in 1885 in Tempe, three years before Tempe's first elementary school was established. By 1921, the date of this photograph, the campus had already begun taking over San Pablo. Note the course of the river and Tempe Butte in the background.

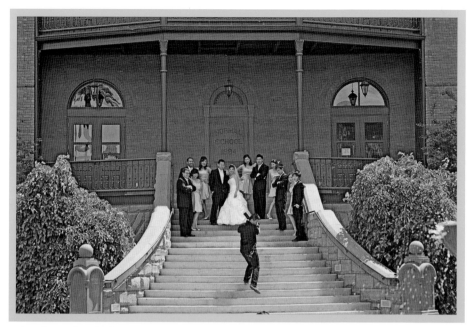

Today, the student body at ASU numbers more than 55,000, the largest enrollment in the nation. One of the first graduating classes stands on the steps of Old Main in the photograph below. A wedding party gathers on steps of Old Main in the photograph above. Old Main, the oldest surviving building on the ASU campus, was built of brick, native granite from Tempe Butte, and red sandstone from Flagstaff in 1898.

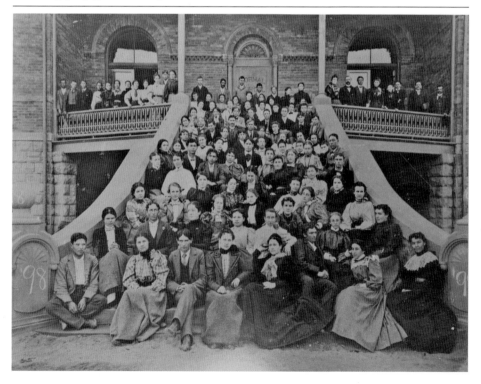

THE TERRITORIAL NORMAL SCHOOL

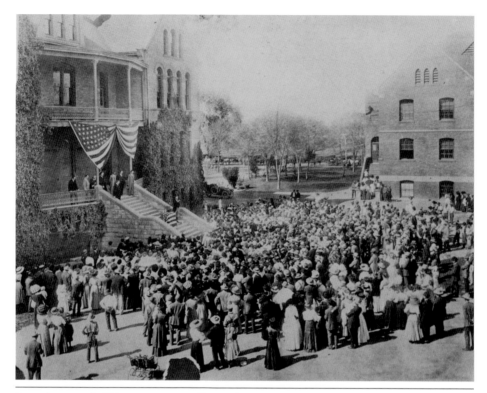

Recently restored, Old Main was originally noted for its Victorian and Queen Anne influences and Richardsonian Romanesque ambience. While visiting Arizona to dedicate Roosevelt Dam, Pres. Theodore Roosevelt (shown above) spoke from the front steps in 1911. Old Main served both academic and administrative functions until the late 1940s. Now the building is home to the ASU Alumni Association.

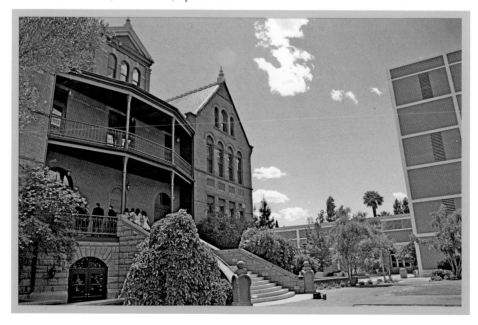

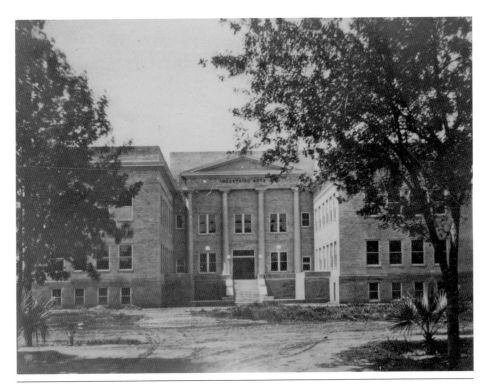

The Anthropology Museum building, constructed in 1914, was designed by noted neoclassical revival architect Norman F. Marsh. This reinforced concrete building is the first and only true neoclassical revival building on campus. Now facing Cady Mall, this building was also the first extension of the college campus west of what was then College Avenue.

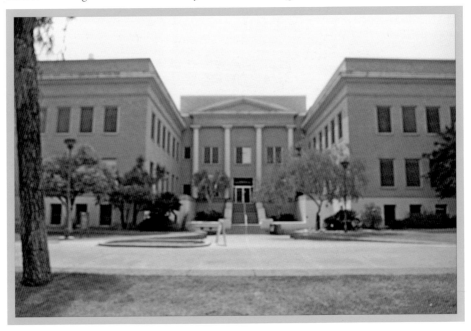

The Moeur Building was constructed under the auspices of the Works Projects Administration in 1939 and is the largest of its kind in Arizona. Distinguished by its Federal moderne style, characterized in part by the vertical emphasis achieved by the pilasters between the windows at the entry the building, it is unique because of the use of adobe bricks in its construction. Named after Dr. B. B. Moeur, the building originally served as an auditorium and a recreation facility.

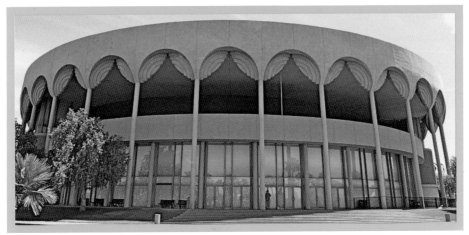

The most distinctive landmark on the ASU campus is the Grady Gammage Memorial Auditorium, completed in 1964. Named after a past president of the college, this structure was designed by Frank Lloyd Wright and based on a performance center planned but never built for the Shah of Iran. Unfortunately, neither Grady nor Wright was able to see the end result of their project, as both died in 1959.

TEMPE TOWN LAKE

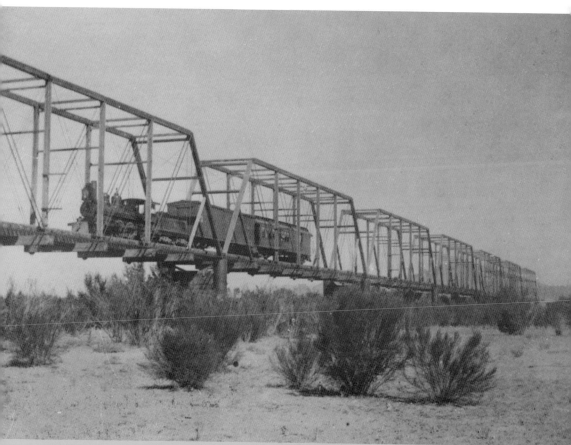

After Roosevelt Dam was built in 1911 and the waters of the Rio Salado were drained off for the Salt River Project, the lake at Tempe disappeared. Note the dry riverbed in this photograph. Except for occasional floods, only a strand-like trickle of water remained. The creation of the Tempe Town Lake changed all that.

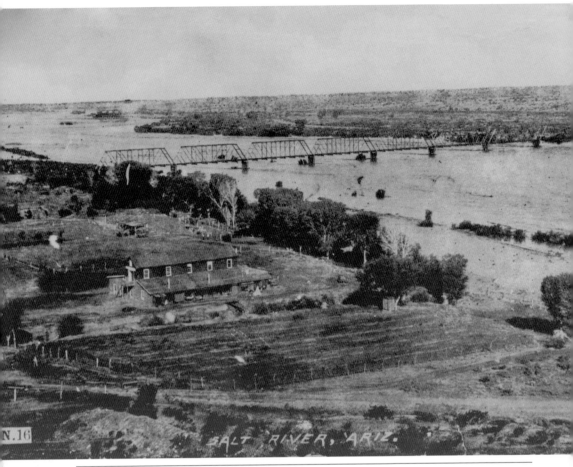

Much like the flood of 1931 (shown above), Tempe Town Lake fills the Salt Lake Valley, bank to bank. Two miles long, occupying 220 acres and containing 977 million gallons of water, Town Lake was completed in 1999. Boaters, rowers, and fishermen are drawn to its waters. Hikers, joggers, incline skaters, and bicycles ply the trails that surround the lake. Over the last 10 years, visitors to the lake have contributed nearly $40 million to the economy.

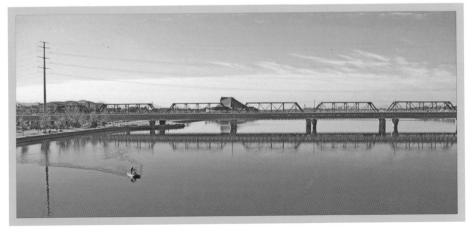

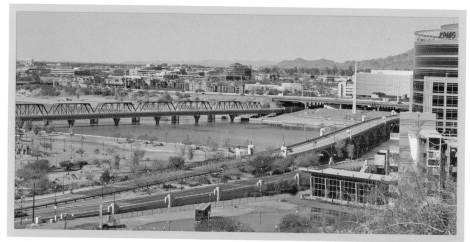

Before Town Lake was created, Tempe Beach Park was built on the riverfront at the northwest corner of First Street and Mill Avenue and only lived up to its name when there was a flood. In 1923, a public pool was constructed on the beach park site by Niels Stolberg, but the property west of the pool to Ash Street (shown here in 1888) was not acquired by the city until 1927.

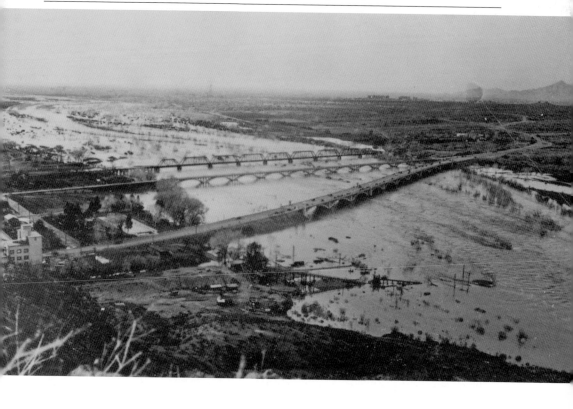

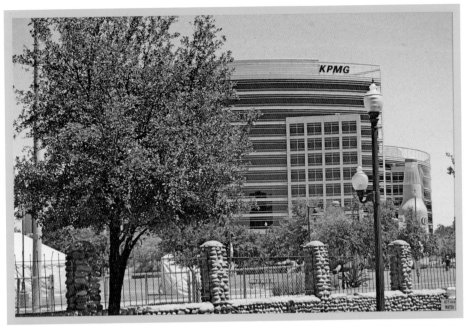

In 1928, a cobblestone bandstand built of local river rock and a baseball field were added. In 1934, a cobblestone bathhouse and wall were added. Finally, cobblestone bleachers were built at the west end of the baseball field, abutting the south end of the Ash Street bridge. Portions of the cobblestone wall and all of the bleachers still remain.

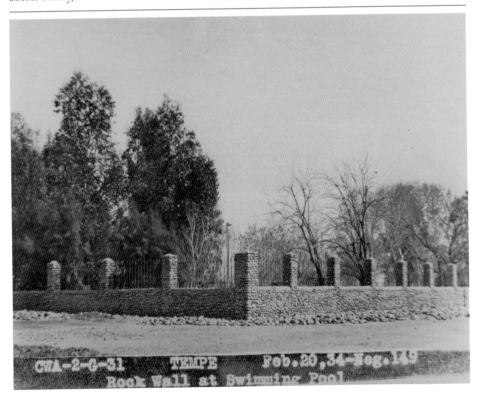

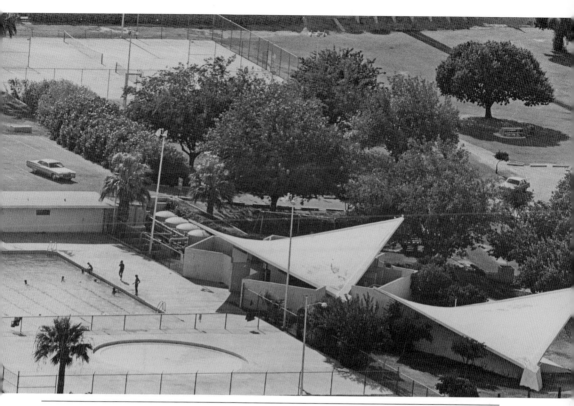

In the 1960s, the pool at the park (the only Olympic-size pool in the state) was replaced with a smaller one (shown in the photograph above) and eventually done away with completely. Renovated in 1999, Tempe Beach Park today draws as many as 500,000 people each year, attending such local events as the New Year's Eve Block Party, Oktoberfest, the Fourth of July celebration, and the Fantasy of Lights. Behind the park sprawls part of Tempe's high-rise commercial district.

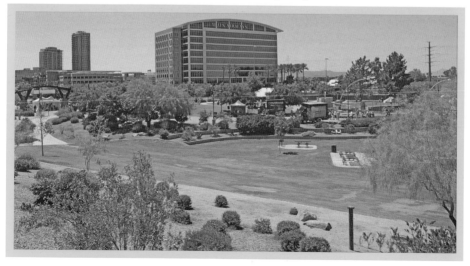

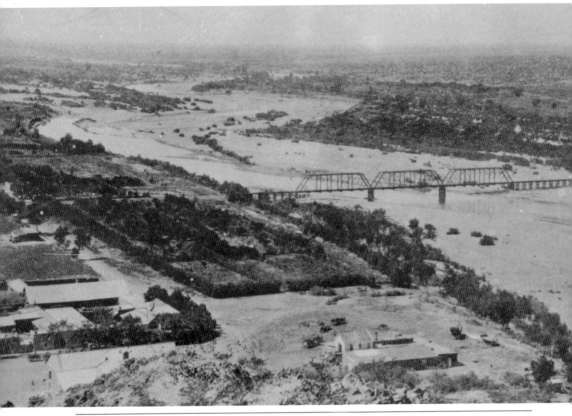

On the south side of Town Lake is the new $65-million Tempe Center for the Arts (the peaked roof above the railroad bridge in the photograph below). On the site is a 17-acre arts park and an 88,000-square-foot contemporary building with restaurant, meeting and administrative facilities, and 600- and 200-seat theaters. Partially blocking the arts center in this photograph is one of the new condominium projects on Town Lake. In the foreground is the Tempe Beach Park.

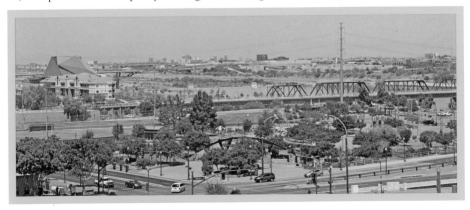

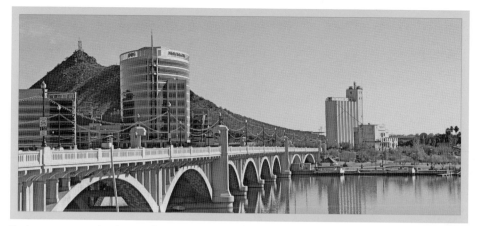

Real estate surrounding Town Lake at $42 a square foot has attracted a plethora of new enterprises. Upon its completion, Hayden Ferry Lakeside will include a hotel complex, three office towers, four luxury condominium buildings, and space for retail and restaurant establishments. Further proposed plans for development at Town Lake include various other mixed-use projects for residences and businesses.

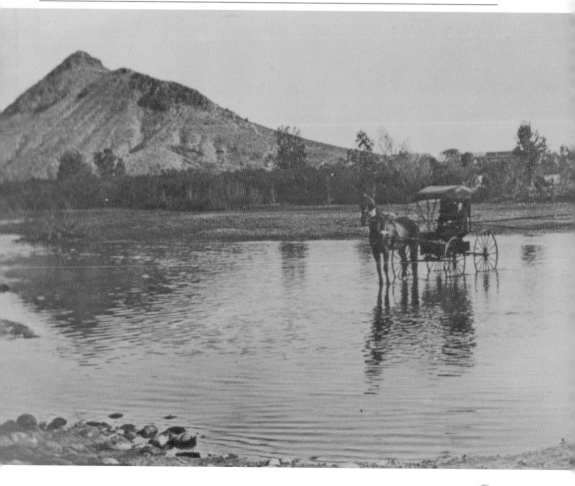

www.arcadiapublishing.com

Discover books about the town where you grew up, the cities where your friends and families live, the town where your parents met, or even that retirement spot you've been dreaming about. Our Web site provides history lovers with exclusive deals, advanced notification about new titles, e-mail alerts of author events, and much more.

MADE IN THE

Arcadia Publishing, the leading local history publisher in the United States, is committed to making history accessible and meaningful through publishing books that celebrate and preserve the heritage of America's people and places. Consistent with our mission to preserve history on a local level, this book was printed in South Carolina on American-made paper and manufactured entirely in the United States.

This book carries the accredited Forest Stewardship Council (FSC) label and is printed on 100 percent FSC-certified paper. Products carrying the FSC label are independently certified to assure consumers that they come from forests that are managed to meet the social, economic, and ecological needs of present and future generations.

FSC
Mixed Sources
Product group from well-managed forests and other controlled sources

Cert no. SW-COC-001530
www.fsc.org
© 1996 Forest Stewardship Council

Find Your Place in History.